Henri de Toulouse-Lautrec

G ERHARD G RUITROOY

NEW LINE BOOKS

Fax: (888) 719-7723
e-mail: info@newlinebooks.com

Printed and bound in Singapore

ISBN 1-59764-103-0

Visit us on the web!
www.newlinebooks.com

Author: Gerhard Gruitrooy

Publisher: Robert M. Tod
Editorial Director: Elizabeth Loonan
Book Designer: Mark Weinberg
Production Coordinator: Heather Weigel
Senior Editor: Edward Douglas
Project Editor: Cynthia Sternau
Assistant Editor: Stacey McNutt
Picture Reseacher: Laura Wyss
Desktop Associate: Michael Walther
Typesetting: Command-O, NYC

Picture Credits

The Art Institute of Chicago 13, 23. 56-57, 65

The Barnes Foundation, Merion, Pennsylvania 34

Bibliothèque Nationale, Paris—Art Resource, New York 98 (right)

The Cleveland Museum of Art 74

Collection H. Hahnloser, Bern—Giraudon/Art Resource 64

Courtauld Institute Galleries, London—Art Resource 11, 115 (left)

The Free Library, Philadelphia 66, 80

Fundaciòn Colecciòn Thyssen-Bornemisza, Madrid—Art Resource 52, 95

Los Angeles County Museum of Art 67

Mahmoud Khalil Museum, Cairo—Art Resource, New York 102

Musée des Arts Decoratifs, Paris—Art Resource, New York 96-97

Musée des Augustins, Toulouse—Giraudon/Art Resource, New York 85, 110

Musée d'Orsay, Paris—Giraudon/Art Resource, New York 16, 27, 48, 53, 61, 71, 90 (right), 92, 118-119, 119-120, 123, 124

Musée Toulouse-Lautrec, Albi—Giraudon/Art Resource, New York 5, 6, 7, 8-9, 10, 14, 15, 18, 20, 24-25, 26, 29, 35, 37, 38, 40-41,42, 47, 49, 50, 51, 55, 58, 59, 62, 63, 70, 72-73, 77, 78, 79, 81, 82, 83, 86, 87, 88-89, 90 (left), 91, 93, 98 (left), 99, 104-105, 106, 108, 111, 113, 114, 115 (right), 116, 117, 122, 125

The Museum of Fine Arts, Budapest—Art Resource, New York 109

The Museum of Fine Arts, Houston 101

The Museum of Modern Art, New York 28, 36

The National Gallery of Art, Washington, D.C. 44-45, 54, 60, 68, 100, 107

Neue Pinakothek, Bayerische Staatsgemaeldesammlungen, Munich 32-33

Ny-Carlsberg Glyptothek, Copenhagen—Art Resource, New York 76

The Philadelphia Museum of Art 31, 39

Private Collection—Bridgeman/Art Resource, New York 22, 46, 75, 94

Puskin Museum, Moscow—Art Resource, New York 19

San Diego Museum of Art—Art Resource, New York 1126

Staatliche Kunstammlungen, Dresden—Art Resource, New York 112

The Tate Gallery, London—Art Resource, New York 84, 103, 127

Victoria & Albert Museum, London—Bridgeman/Art Resource, New York 43

CONTENTS

INTRODUCTION

Henri-Marie Raymond de Toulouse-Lautrec-Montfa was born on November 24, 1864 at the Hôtel du Bosc in Albi, the house of his great aunts, located at the foot of the town's imposing Gothic cathedral. Lautrec was a direct descendent of the counts of Toulouse, who have a long and impressive history in the south of France. His parents, Alphonse Charles Jean Marie, Count de Toulouse-Lautrec-Montfa, (1838–1913) and Marie Marquette Zoè Adèle Tapié de Céleyran (1841–1930) were first cousins twice over and diametrically opposed in character. His father was a former military officer and accomplished falconer. The Count was a strong man who loved the out-of-doors and the aristocratic sports of hunting and horseback riding. He also had an eccentric penchant for historical costumes.

Lautrec's mother was a shy, tender person with a good heart, who was devoted to her first-born son and treated him lavishly. At the time of her marriage, she was a resident of the Château de Céleyran in the commune of Salles d'Aude (Aude), near Narbonne. Young Henri spent much of his youth drawing and painting in the fields and vineyards of this country estate.

In 1872, accompanied by his mother, Henri went to Paris to become a pupil at the Lycée Fontanes (the present Lycée Condorcet). There he met his lifelong friend Maurice Joyant, whose biography of Lautrec is an early and valuable source of information. In January of 1875, Henri left school for health reasons and his mother accompanied him to a clinic at Neuilly, near Paris, where he was to stay for over a year. At his father's residence, the Château du Bosc, in the commune of Camjac (Aveyron), Henri began to imitate his uncles in painting and drawing. René Princeteau (1839–1914), a painter of some renown and a friend of Henri's father, taught Henri drawing and painting.

In 1878, Henri had his first injury. While trying to get up out of a low chair, he slipped on a polished floor and broke his left thigh. The following year he fell and broke his right thigh. His mother took him to various spas to improve his health, but the injuries atrophied the growth of his legs. Henri spent much time in bed, reading and drawing. The caricatures that accompany his letters show how he buoyed his spirits during this time. He continued his studies during his convalescence and passed his baccalaureate in November of 1881, in Toulouse, after failing his first attempt at the exam in Paris.

Early Studies and Development

Lautrec began to study painting more seriously with Princeteau in Paris. In April 1882, he was accepted as a student in Léon Bonnat's studio. Bonnat found Lautrec's drawing "simply atrocious." When Bonnat closed his atelier in September of the same year, Lautrec entered Fernand Cormon's (1845–1924) studio. At Cormon's, Lautrec met fellow students Louis Anquetin, Emile Bernard, Vincent Van Gogh, and François Gauzi (1861–1933), who became a lifelong friend.

Self-Portrait

c. 1882–1883, oil on board; (40.5 x 32.5 cm). Musée Toulouse-Lautrec, Albi.

Besides a number of amusing caricatures of himself, Lautrec painted only two self-portraits. In this work, the mirror, necessary for all self-portraits, has been included and turned into a major element. This canvas seems never to have been shown publicly during the artist's lifetime.

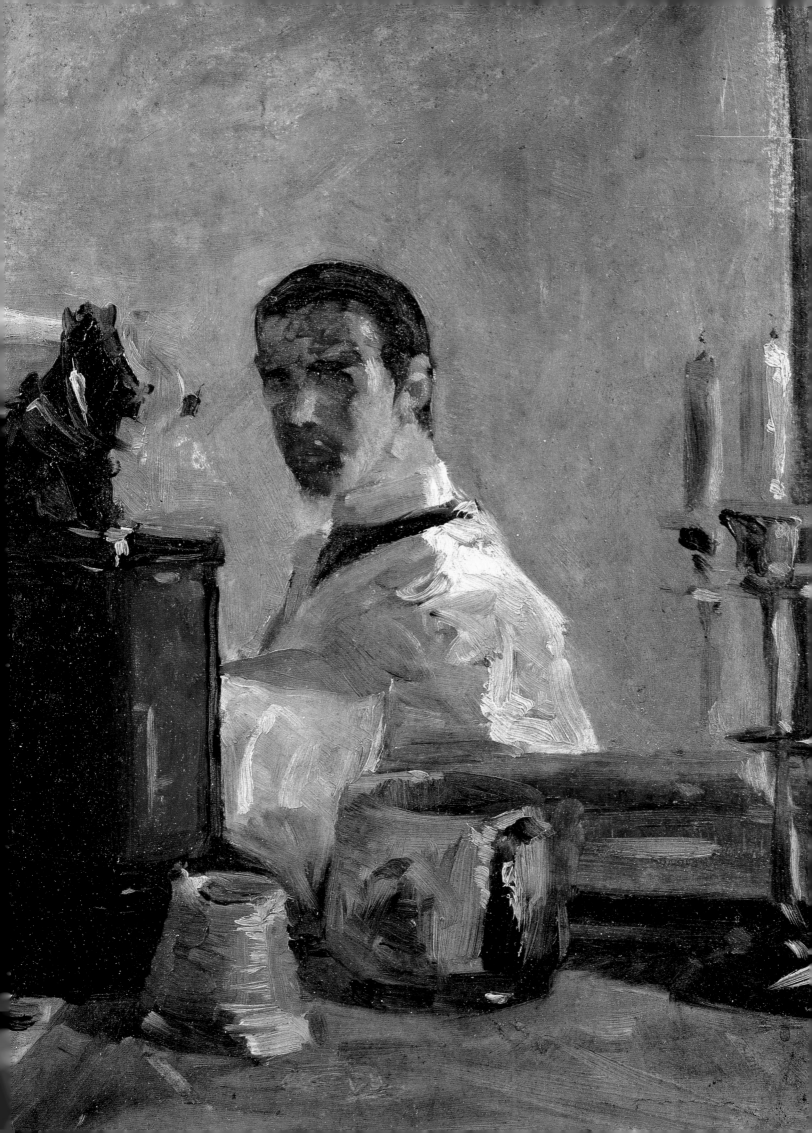

Comtesse Adèle-Zoé de Toulouse-Lautrec, the Artist's Mother

c. 1883, oil on canvas; (93.5 x 81 cm). Musée Toulouse-Lautrec, Albi.

Painted with great simplicity and a limited tonal range, this is one of Lautrec's
most important portraits of his mother. The Countesse's dress is a symphony
in white, and mauve and green shadows define the space around her.
The muted colors of the room are in keeping with her pensive expression.

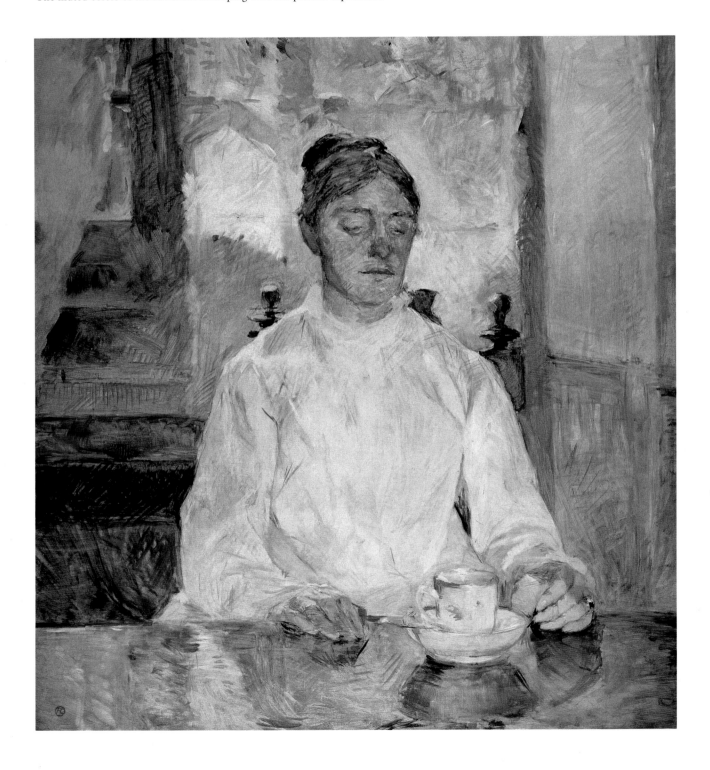

Lautrec remained in Cormon's Montmartre studio for five years, improving his draftsmanship and developing his own understanding of his art. He spent mornings in the studio, and painted outdoors with classmate, Henri Rachou, in Rachou's garden. Lautrec lived among young artists with new ideas in a turbulent artistic world. *"Vive la Révolution! Vive Manet!* ('Long live the Revolution! Long live Manet!') the breeze of Impressionism is blowing through the studio," he proclaimed in a letter to his mother.

The artist's departure from the past was a gradual one, a step by step transition during which he took up subjects of modern life while working in a freer technique. He began to use the lighter colors favored by the Impressionists, and to employ a little-used technique called *peinture à l'essence*, invented by Jean François Raffaëlli (1850–1924). This method employs pigments thinned with turpentine; the support, usually cardboard, quickly absorbs the volatile substance, leaving the dry pigments on the surface. This procedure accounts for the flat quality of the colors and requires assured draftsmanship.

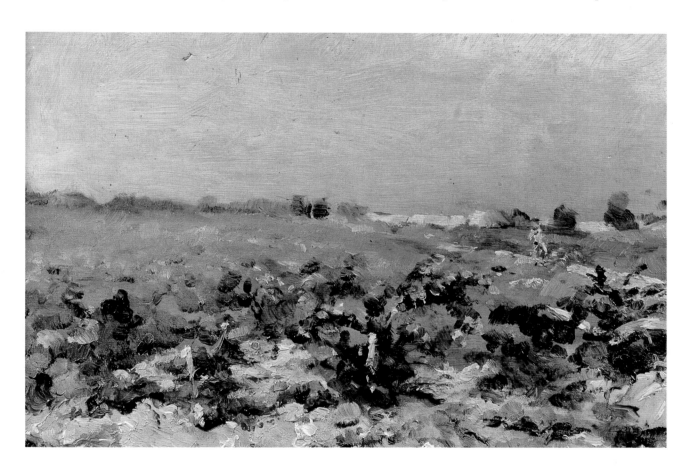

Céleyran: View of the Vignards

1880, oil on board; 9 1/4 x 6 1/2 in.
(23.8 x 16.6 cm). Musée Toulouse-Lautrec, Albi.
Landscapes were treated as accessories in Lautrec's later works. During his youth, he painted several views of the fields surrounding his mother's home at Céleyran. The colors are earthy, but the technique is clearly influenced by the Impressionist method of applying small dots onto the canvas.

Following page:
Alphonse de Toulouse-Lautrec-Monfa Driving his Mail-Coach to Nice
c. 1881, oil on canvas; 29 1/4 x 21 1/2 in. (38.5 x 51 cm). Musée Toulouse-Lautrec, Albi.
This early work was probably executed under the instruction of René Princeteau, an artist and family friend who taught the young Toulouse-Lautrec painting and drawing before he entered Léon Bonnat's studio in Paris in 1882.

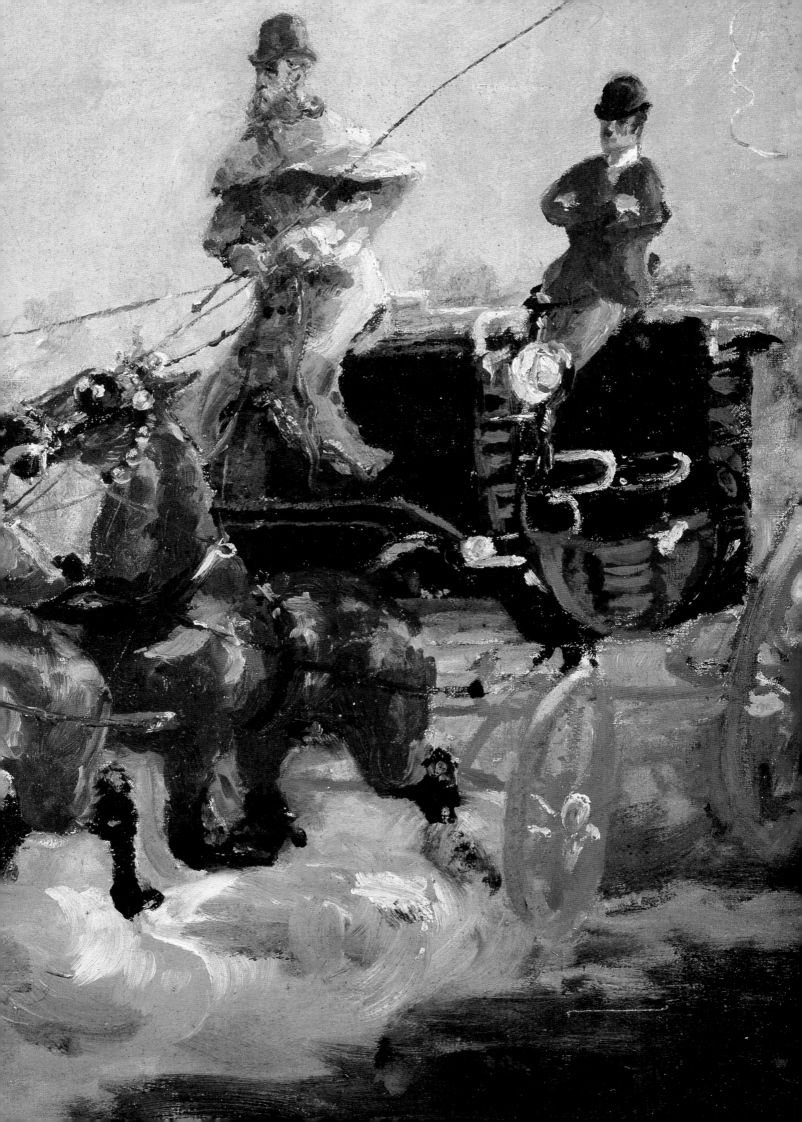

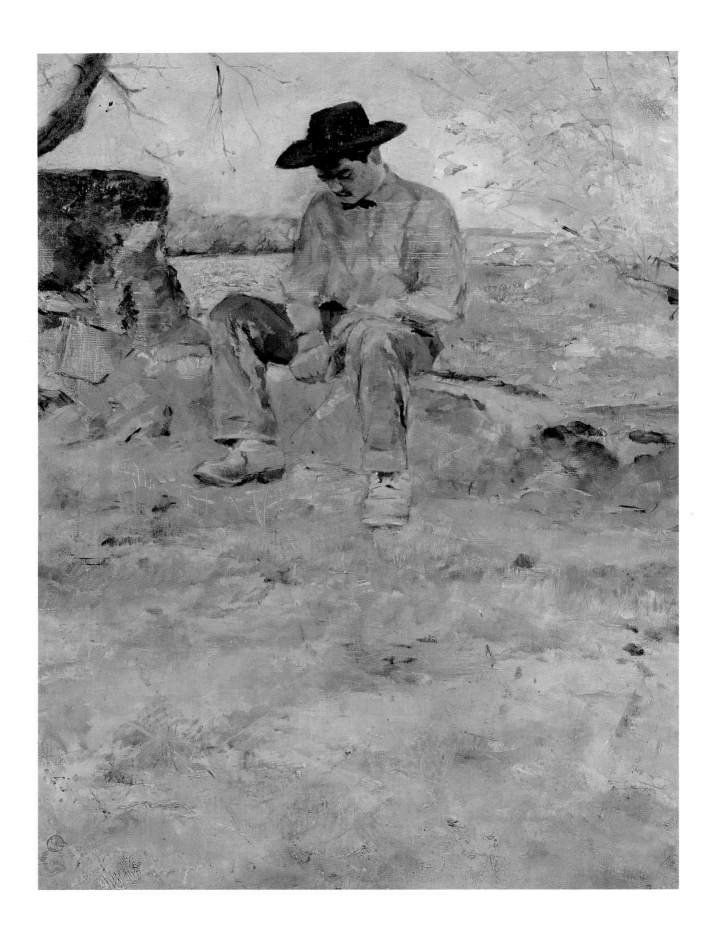

Jane Avril Entering the Moulin Rouge

1892, oil and pastel on three sheets of cardboard; 39 3/4 x 21 1/2 in. (102 x 55 cm). Courtauld Institute Galleries, London. Dressed as an elegant bourgeois lady in her elaborate hat and large fur collar, Avril is caught at a rather private moment while entering the Moulin Rouge. Her respectable appearance conceals the exuberant dancer who thrilled audiences at the Moulin Rouge.

The Young Routy

c. 1883, oil on canvas; 24 x 19 in. (61 x 49 cm). Musée Toulouse-Lautrec, Albi. "Landscape is and must be nothing more than an accessory; the pure landscape painter is a dumb brute. Landscape must serve only to enhance our understanding of the character of the figure."

—HENRI DE TOULOUSE-LAUTREC

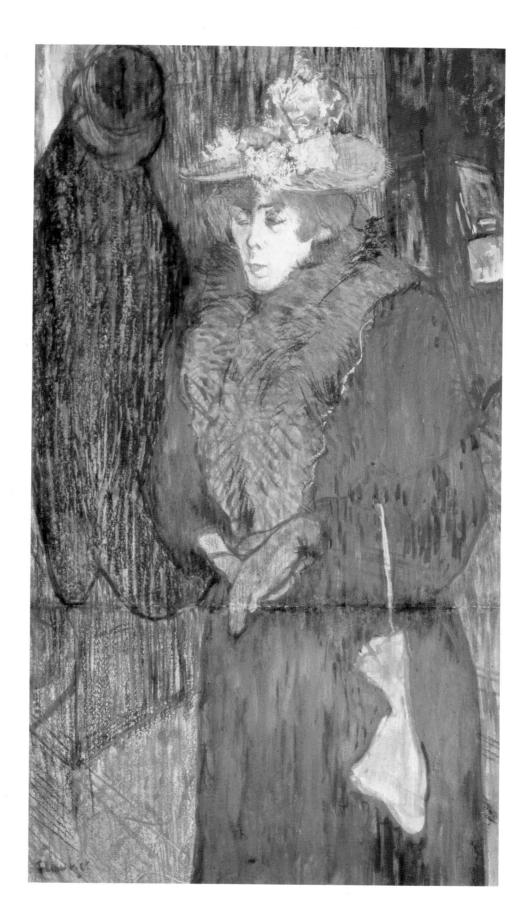

Montmartre

Lautrec immersed himself in the life of Montmartre. He lived among the lower classes, and began frequenting the district's clubs and brothels while still a student. He met anarchists and anti-bourgeois characters, such as the singer Aristide Bruant. Lautrec soon began rendering the *demi-monde* of Montmartre's cafés and nightclubs in his portraits of singers, actors, and prostitutes.

Like many of his contemporaries, Lautrec used the women of the district as models and as prostitutes. Whether or not his unfortunate physical condition contributed to his penchant for prostitutes has been the center of much psychoanalytical debate. It is likely that Lautrec's communion with the women of Montmartre's brothels nourished his self-esteem and provided him with an acceptance he did not enjoy among his own class.

As far as is known, the only woman who ever fell seriously in love with Lautrec was Suzanne Valadon (1867–1938). Her real name was Marie-Clémentine Valade, and she came from the Limousin region in central France. Like many other young women from the provinces, who were uprooted by the industrial revolution of the nineteenth century, Valadon came to Paris to find work. She began to paint and draw in the mid-1880s while working as a laundress. Later she became a circus equestrienne and trapeze artist. After she was injured in an accident, she became an artist's model, sitting for Degas and Puvis de Chavannes.

It was at this time that Lautrec met and fell in love with Valadon. For the next two years, they were often seen together in Montmartre's clubs and cafés. They lived together for a short while, but Lautrec broke off the relationship when Valadon feigned suicide in a vain attempt to force him to marry her. They did continue to see each other intermittently, and Valadon became a successful painter in her own right.

Lautrec was never again involved in a romantic relationship. The young, sentimental artist became a pitiless observer of the women and the opportunistic night hawks who frequented the district's clubs and brothels. His brush neither embellished nor rejuvenated his subjects. He portrayed the glamorous stars of Montmartre's theaters in the unflattering glare of the footlights. Nevertheless, his models always retained their dignity and the artist's sympathy. His family allowance permitted him to paint what pleased him and commissioned works are therefore extremely rare.

Lautrec's problematic relationship with the female sex was an important element in his emotional life and artistic endeavors. Nevertheless, it should not be the sole basis on which to view his work. The cultural and economic forces that dominated were equally significant in determining the development and direction of Lautrec's oeuvre.

After his mother bought the Château de Malromé (Gironde) in the southwest of France and left Paris for good, the young artist was left on his own. For about two months he lived in the Montmartre apartment of Lili and Alfred Grenier, a fellow painter at the Cormon studio. Nestled in the bastion of the Paris Commune among Montmartre's writers, musicians, and performers, Lautrec's work flourished.

Under the influence of Degas (1834–1917) and Jean-Louis Forain (1852–1931), Lautrec and many other young artists focused on scenes of metropolitan life and popular pastimes. Even the more conservative artists of the Salon, such as Jean Béraud, painted detailed reconstructions of public life in outdoor balls and caféhouses, which could be read as objective records of contemporary life. For Lautrec, only the figure counted.

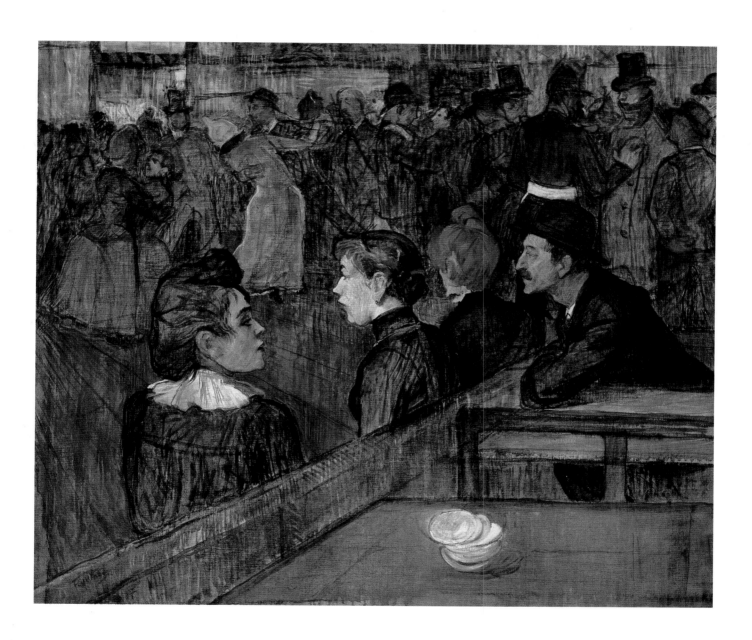

At the Moulin de la Galette

1889, oil on canvas; 34 1/2 x 39 1/2 in. (88.5 x 101.3 cm). Mr. and Mrs.
Lewis Larned Coburn Memorial Collection, 1933.458, The Art Institute of Chicago.
By the end of the nineteenth century, the few remaining windmills on Montmartre
had been turned into dance halls and bars which offered entertainment to many
Parisians. In this work, Lautrec concentrated on the crowd, rather than the locale.

The Milliner

1900, oil on board; (61 x 49.3 cm). Musée Toulouse-Lautrec, Albi.
According to the writer Paul Leclerq, the model was chosen for her red-gold hair: "The transient mistress of one of his friends remained one of his best companions for years. She was a young milliner, with masses of blond hair and the wide awake face of a squirrel."

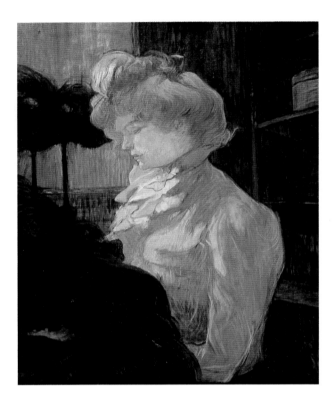

The Young Independents

Lautrec was part of the avant-garde that included Seurat, Anquetin, and Bonnard—the young independents of the late nineteenth century who were determined to surpass the older generation. Their philosophy advocated pleasure over morality, and celebrated erotic and alcoholic excess, and their work provoked and fascinated with its elements of sexual exploitation and class voyeurism. Their philosophy and subject matter was in harmony with the entertainments of Montmartre. The district's entrepreneurs happily employed the young avant-garde artists as set and poster designers.

Lautrec's career also coincided with a radically renewed development of public institutions, including the sudden growth of the publishing industry. Educational reforms in the mid-century created new readers, and the public's improved literacy rate improved circulation. In 1870, daily newspapers sold one million copies in Paris, by 1910 the number had increased fivefold.

The technological progress in the printing industry allowed better and cheaper mass production of illustrations. Artists seized the opportunity to publish their works in ever greater numbers. When the bans on political and social topics were lifted in 1881, new freedom of expression was made possible. The public could read uncensored comments on events in contemporary society, and satirical publications flourished.

Caricatures became popular in publications like *Le Rire*, which showcased the work of numerous artists and writers. Lautrec's often cited "biting humor" made him a suitable contributor. Lautrec usually played down his aristocratic background with an ironical detachment, but it helped to make him the perfect bohemian. He clearly despised the ambition of nouveau-riche and the French middle class to imitate the old aristocracy through their newly acquired means.

Lautrec was not without his own detractors, but he enjoyed positive critical response to his work. His posters were commercially successful and easily accessible to people of differing backgrounds and class. They drew audiences to Montmartre's theaters and cafés, and strengthened the popularity of Montmartre's entertainers.

Reine de Joie

1892, lithograph; 58 1/4 x 38 3/4 in.
(149.5 x 99 cm). Musée Toulouse-Lautrec, Albi.
The novel *Reine de Joie* ("Queen of Joy") by Victor Joze is remembered today for Lautrec's poster, and his cruel depiction of the book's characters. The story, about an affair between a prostitute and a wealthy banker, caused a scandal upon its publication.

Reine de Joie

par J Victor Joze

chez tous les libraires

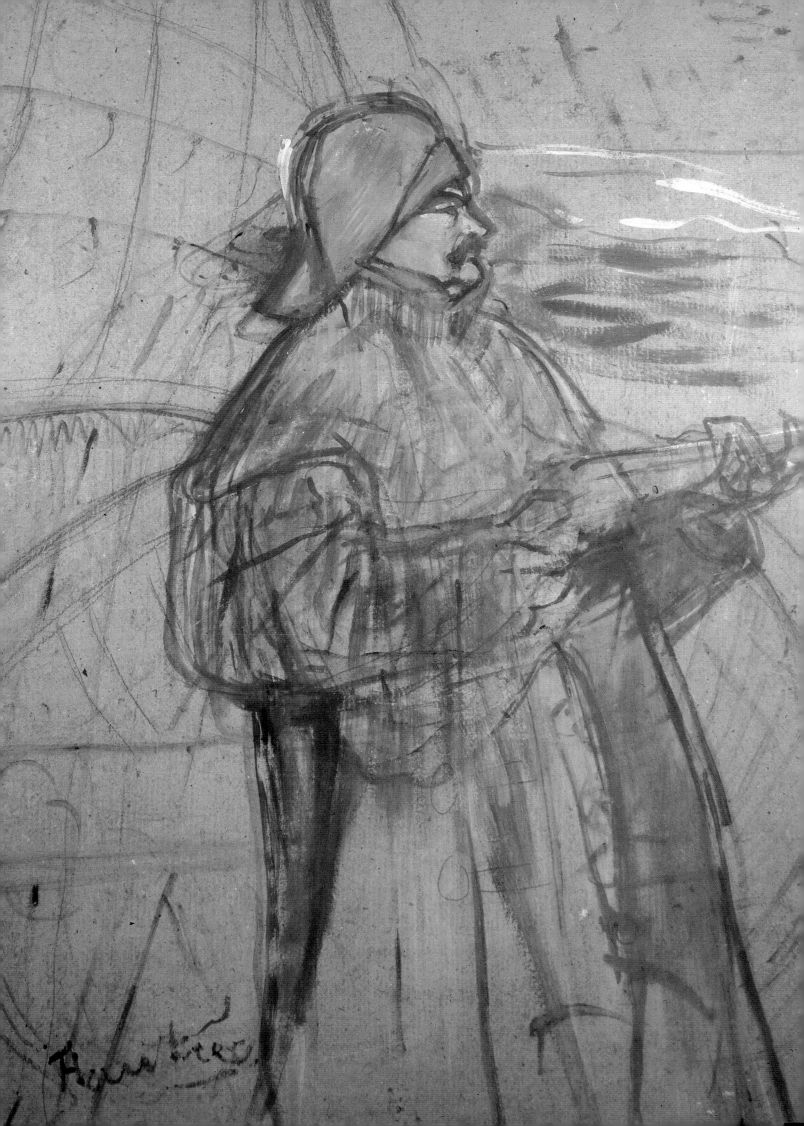

Final Illness and Death

For about fifteen years, Lautrec produced works in his own characteristic style. His enormous creative output was cut short by mental and physical illnesses which were worsened by alcoholism and syphilis. During an attack of delirium tremens at the house of the Natansons in Villeneuve-sur-Yonne, in the summer of 1897, he saw huge spiders in his room and fired at them with a revolver. After suffering hallucinations while walking in the streets of Paris, Lautrec's family had the artist committed to a mental hospital. The conservative press leapt on Lautrec's dementia and launched personal attacks on the artist and his work. Aware of his physical and mental decline, Lautrec wrote to his father begging to be released: "Papa, this is your chance to do the decent thing. I am confined, and all confined things die."

A three-month-stay in the clinic, brought Lautrec temporary relief from his unstable and troubled condition. He recovered some of his health, and was able to work and travel again. He even enjoyed a brief affair with Louise Margouin (Louise Blouet), a milliner whose features and red hair Lautrec captured in one of his last paintings (*The Milliner*). From October, 1900 to April of 1901, he lived in Bordeaux where he had a fleeting, and frantically productive period inspired by two productions at the local opera. Despite the surveillance of his chaperon, Paul Viaud and the efforts of his friends, Lautrec began to drink again and his health deteriorated.

In February, Lautrec suffered a stroke that temporarily paralyzed him. His alarming bouts of amnesia became more frequent. Realizing that his health was now rapidly deteriorating, Lautrec heeded Joyant's suggestion to make a thorough inventory of his Paris studio to prepare for a major retrospective. The effort exhausted Lautrec. He returned to Malromé, and died there on September 9, 1901, in his mother's arms. Lautrec was thirty-seven.

His father, Alphonse Toulouse-Lautrec, wrote a deeply moving letter to Joyant asking Lautrec's friend to become the executor of the estate:

> There is no generosity in my passing over to you any paternal rights that I may have as the heir to any work by my departed son: your brotherly friendship took the place of my feeble influence with such gentleness that it seems only right to ask you to continue to play this charitable role if you will, purely for the satisfaction of your tender feelings for your college friend; I do not envisage becoming a convert, and now that he is dead I do not intend to start singing the praises of work that during his lifetime was nothing to me but brazen, daring sketches . . . You have greater faith in this work than I do and you are right.

Thanks to his family's generosity and to the indefatigable efforts of Joyant, Lautrec's estate was turned over to his native city of Albi in 1919, creating the largest collection of his work anywhere. Studies on his life and work began to be published very soon after Lautrec's death. In 1922, at the opening of the Musée Toulouse-Lautrec, Maurice Joyant proclaimed: "Gentlemen of Albi, we hereby entrust to your care and in perpetuity the work of the painter Henri de Toulouse-Lautrec, which will become an object of pilgrimage for all lovers of art."

Maurice Joyant

1900, oil on cardboard; 37 1/2 x 26 in. (96 x 66.5 cm). Musée d'Orsay, Paris.

This portrait of Maurice Joyant is based on a photograph of both men taken during a fishing expedition around 1899. It is one of Lautrec's last works. Joyant was a lifelong friend of the artist, and became executor of Lautrec's work after the artist's death.

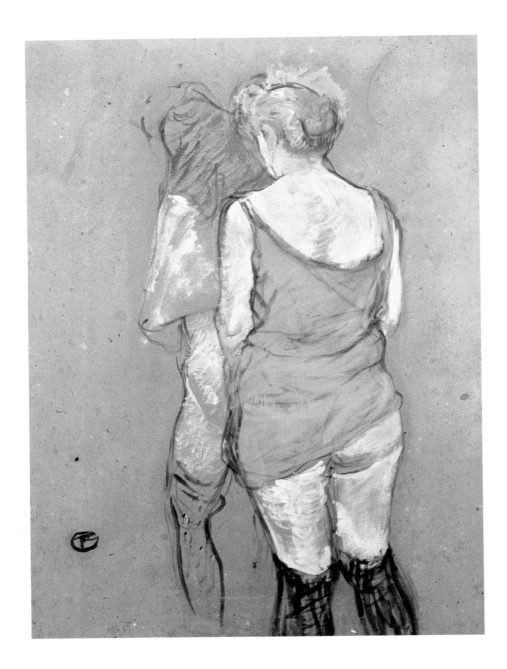

Study for *The Medical Inspection:* Two Women, Partially Undressed, Seen from Their Back

c. 1894, oil on cardboard; 21 x 15 1/4 in. (54 x 39 cm). Musée Toulouse-Lautrec, Albi. Preparing themselves for the mandatory medical inspection, two women are seen from the back lifting their chemises. The more fully rendered one, Gabrielle, often posed for Lautrec. The painter focused on the transparent folds of fabric covering the woman's behind.

Yvette Guilbert Singing "Linger, Longer, Loo"

1894, oil on cardboard; 22 1/2 x 16 1/4 in. (57 x 42 cm). Pushkin Museum, Moscow. This painting shows Yvette Guilbert (1867–1944) performing a famous English song of the period. It served as a study for an illustration in the satirical newspaper *Le Rire* in 1894 and was again used as a lithograph in Lautrec's Guilbert album.

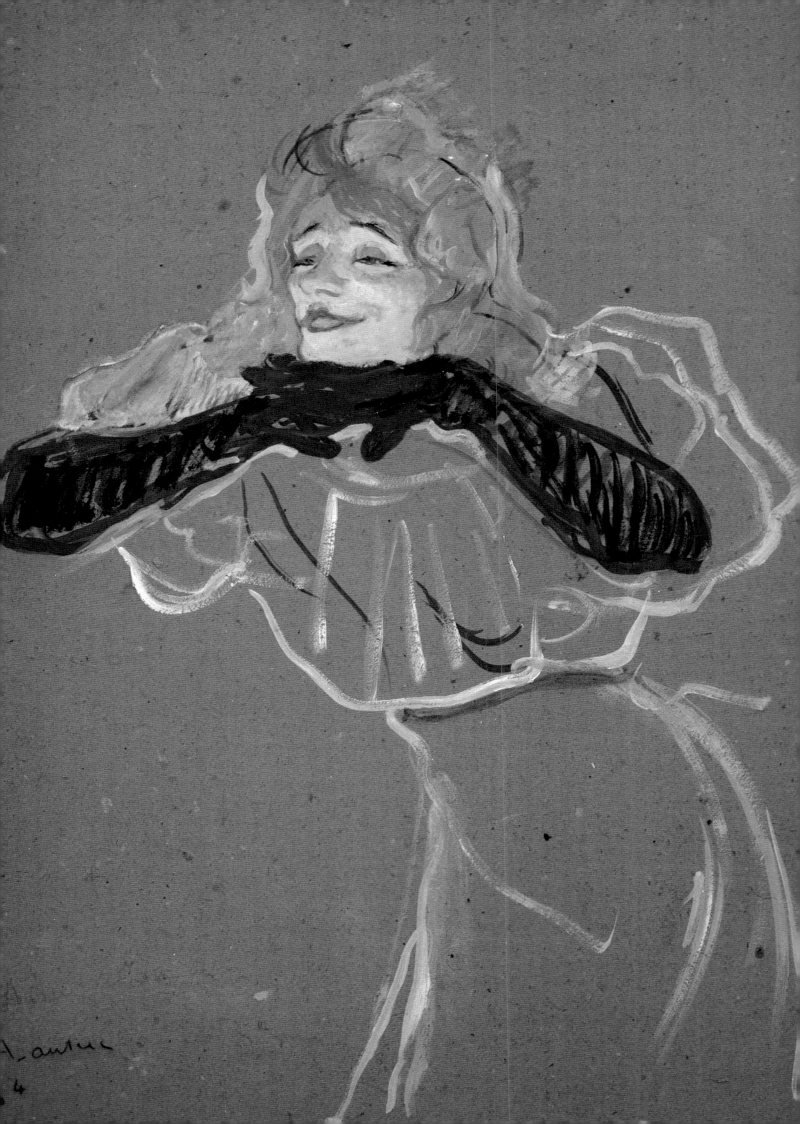

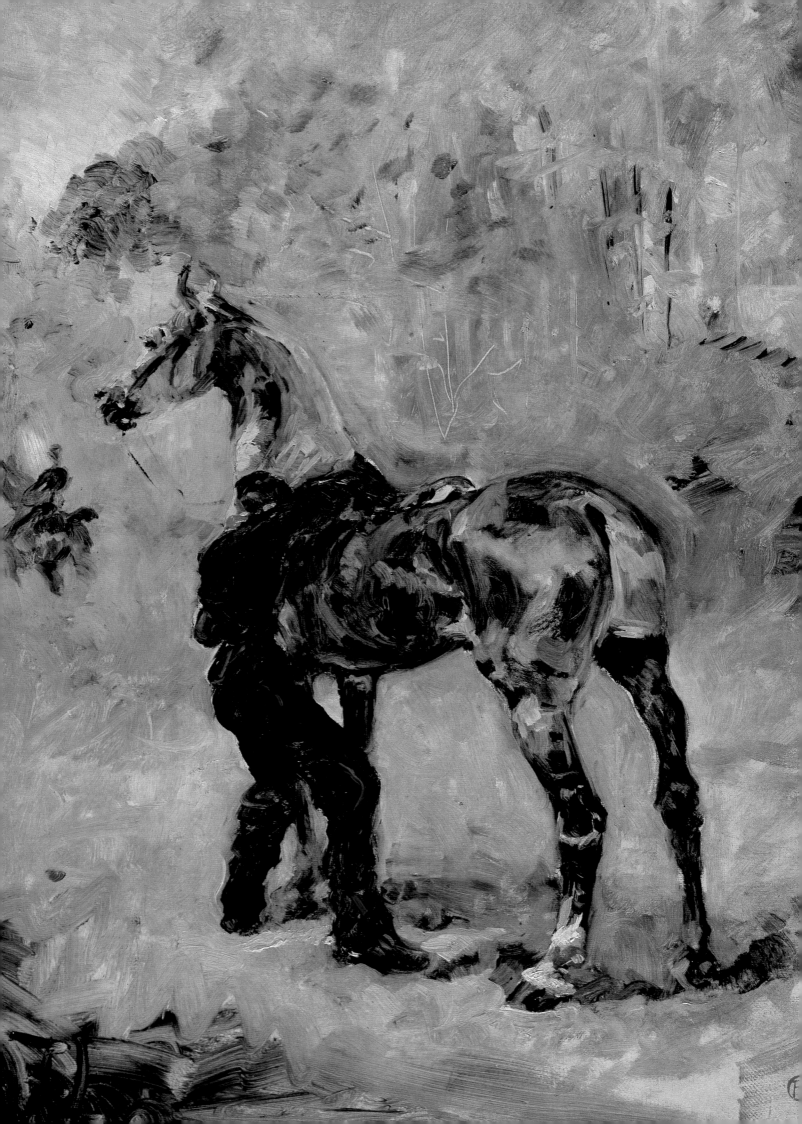

EARLY YEARS AND LIFE IN MONTMARTRE

Henri Toulouse Lautrec spent most of his childhood at the Château du Bosc, about thirty miles north of Albi. Drawing and painting were common pursuits in Lautrec's family, and both his father, Alphonse, and his father's brother, Charles, often spent quiet evenings drawing and sketching. It was in this family circle that the precocious boy made his first attempts as a draftsman.

When Henri was eight years old, he moved with his parents to Paris to attend school at the Lycée Fontanes. The family lived in the Hôtel Pérey near the Madeleine. His father seems to have had a studio there, and his friend René Princeteau, an animal painter of some renown, frequently visited the Lautrec family. Princeteau, a deaf-mute, encouraged and inspired the boy whose physical frailty and ill health were already evident. The margins of Henri's schoolbooks and letters, preserved at the museum in Albi, are filled with sketches and caricatures, evidence of the lively talent that impressed Princeteau.

In May 1878 and August 1879, Henri had two minor falls that broke first his left and then his right thigh. A rare bone disease is thought to have caused the fractures. The bones did not heal completely, and Henri's legs atrophied, making it impossible for Lautrec to walk without difficulty. Alone with his books, Henri tried to entertain himself during his prolonged convalescence: "I draw and paint as much as I can, so much that my hand gets tired of it."

Visits to spas during the following years did not improve his condition. To what extent Lautrec's physical disability influenced his choice to become an artist remains a matter of speculation. There is no doubt that his early work showed facility and assurance. His first attempts in painting show Princeteau's influence especially in the subject matter—horses, dogs, and occasionally soldiers.

Early Training

In the spring of 1881, Lautrec decided to embark an artistic career despite his father's reservations. He traveled to Paris where he spent short periods of time at Princeteau's studio. Through his teacher, Lautrec became acquainted with other painters. Princeteau's atelier was located in the same block as that of other artists, in particular Jean-Louis Forain, whose works of urban life were to become of considerable influence on Lautrec's later development.

Lautrec's most successful work from this time, painted when the artist was in his teens, is the *Artilleryman Saddling His Horse*. The dynamic force of movement and sinuous strength is evoked with great skill. The aerial perspective that suggests space, and the use of different gradations of green hues shows remarkable ability and talent. This painting and other works of his youth are still anchored within his family life. Most are characterized by a rather conservative approach. Lautrec's next step was towards a

Artilleryman Saddling His Horse

1878 or 1881, oil on canvas; 19 3/4 x 14 1/2 in. (50.5 x 37.5 cm). Musée Toulouse-Lautrec, Albi.

The subject was inspired by military maneuvers which took place near the family's Château du Bosc in August–September of 1878, when the artist was only fourteen years old. It is the most finished of the studies made during Lautrec's early years, and may have been executed under the tutelage of René Princeteau.

professional training. His dream was to enter the studio of the most eminent painter of his time, Alexandre Cabanel (1823–1889), who was an institution in the art scene dominated by the École des Beaux-Arts. Competition to enter Cabanel's studio was fierce. Princeteau introduced Lautrec to Léon Bonnat (1833–1922), a skillful, but equally academic painter, who taught a theory of values based on his study of Rembrandt and Ribera. Bonnat was the

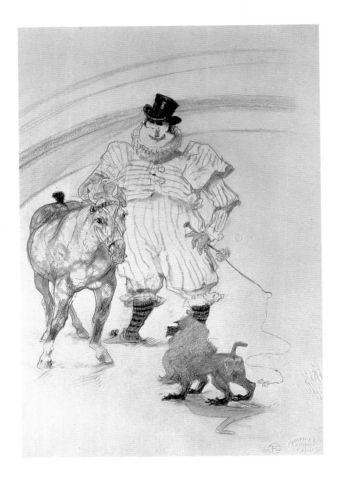

At the Circus—Performing Horse and Monkey

1899, black chalk with estompe, colored crayons, and graphite; 17 x 10 1/2 in. (44 x 26.7 cm). Gift of Tiffany and Margaret Blake, The Art Institute of Chicago.

Lautrec had a strong attachment to the circus and repeatedly made it the subject of his paintings. This comical encounter between a clown as animal trainer, a horse, and a monkey was drawn from memory during Lautrec's stay at a clinic in Neuilly, where he was treated for alcoholism.

leading exponent of an "official" type of portrait. After reviewing his future student's canvases, Bonnat announced: "You have some sense of color, but you need to draw and draw." At Bonnat's studio, Lautrec was able to draw and draw. He worked with life models daily, and his worked was reviewed every week. It was on one of these occasions that Bonnat said: "Your painting isn't bad, it's stylish . . . but your drawing is simply atrocious."

Lautrec spent three months with Bonnat, and then departed to join his family during the summer recess of 1882. When he returned to Paris to resume his studies, Lautrec learned that Bonnat was closing his studio. "Bonnat let *all* his students go," Lautrec announced. With many of his classmates, the artist entered the studio of Fernand Cormon (1854–1924), who was known for his paintings of biblical and historic subjects. Cormon was also an academic painter, but of a different character than Bonnat. To Cormon's credit, he encouraged his students to find their own artistic expression and was open to innovations. Lautrec wrote to his uncle, Amédée: "My new boss is the thinnest man in Paris. He often drops in on us, and wants us to have as much fun as we can painting outside the studio."

Lautrec spent five years in Cormon's studio, where he studied with fellow artists Emile Bernard, Vincent Van Gogh, Louis Anquetin, Albert Grenier, and François Gauzi, who became a lifelong friend. During this time, Lautrec produced over two hundred academic life drawings that attest to the seriousness with which he pursued his career.

At the Circus

The circus was a popular form of entertainment. It had already provided colorful subject matter for Degas, Seurat, and Princeteau. Lautrec visited the Cirque Fernando with Princeteau in the early 1880s, and immediately developed a passion for it. The circus was conveniently located near his Montmartre studio. Lautrec often attended this establishment during the height of its popularity in 1886 and 1887—a period of transition in his career. His large and ambitious *Equestrienne (At the Circus Fernando)*

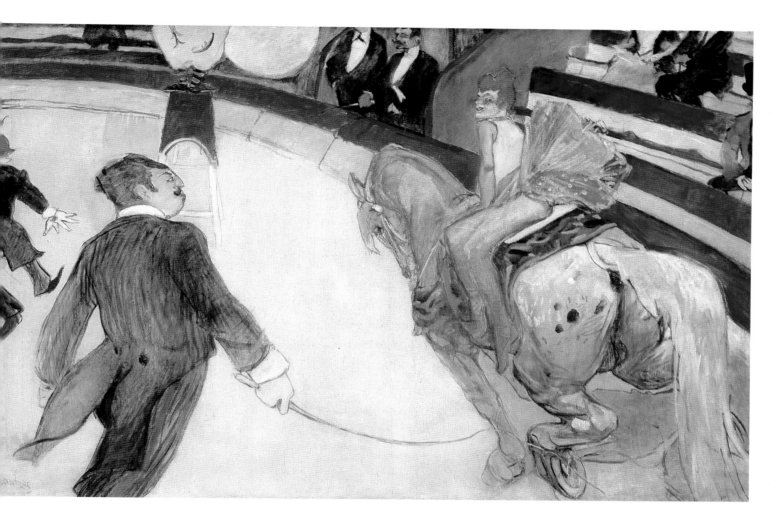

was shown at the exhibition of *Les XX* in Brussels in February of 1888. It is one of the earliest images of Montmartre in Lautrec's work.

The evolution of this work can be followed step by step. First, Lautrec covered the entire canvas with a layer of pink-white which he preserved for the ring. Then he added the curved red stripes of the seats which provide a structure. The figures were defined next, the ringmaster in blue and mulberry-violet, the horse in gray-violet. Various greens for the saddle, the acrobat's bodice, and the background of a stage entrance are freely applied. Lautrec apparently painted quite quickly since some changes, such as the ones around the ringmaster's head, are still visible. The improvised quality may be intentional, or it may be that the pressing deadline of the upcoming exhibition made it

Equestrienne (At the Circus Fernando)

1887–1888, oil on canvas; 40 1/4 x 63 in. (103.2 x 161.3 cm). Joseph
Winterbotham Collection, 1925.523, The Art Institute of Chicago, Chicago.
Lautrec became known for his depictions of typical scenes of Montmartre, which included the Cirque Fernando with its famous acrobatic performances. He appears to have worked very quickly on this canvas—leaving drips and some visible corrections, seen around the ringmaster's head.

impossible to rework every detail. The audacious cropping of the composition cuts off both clowns—one on the left, the other standing on a pedestal—as well as most of the audience. The nearly palpable tension in the ring and the menacing gaze of the ringmaster are not muted by a corresponding counterpart among the spectators. The acrobat on the horse is about to prepare herself for a difficult feat,

**The Hangover
(Geule de Bois)**

*c. 1887–1888, black and
blue crayons, brush and
black ink on discolored paper;
19 1/4 x 24 1/2 in.
(49.3 x 63.2 cm). Musée
Toulouse-Lautrec, Albi.*
Toulouse-Lautrec expressed
the depravity of the poor
and the overbearing social
pressure endured by the
lower class with unique
force and vigor. Lautrec's
friend Suzanne Valadon
modeled for this work, as
well as for a related painting.

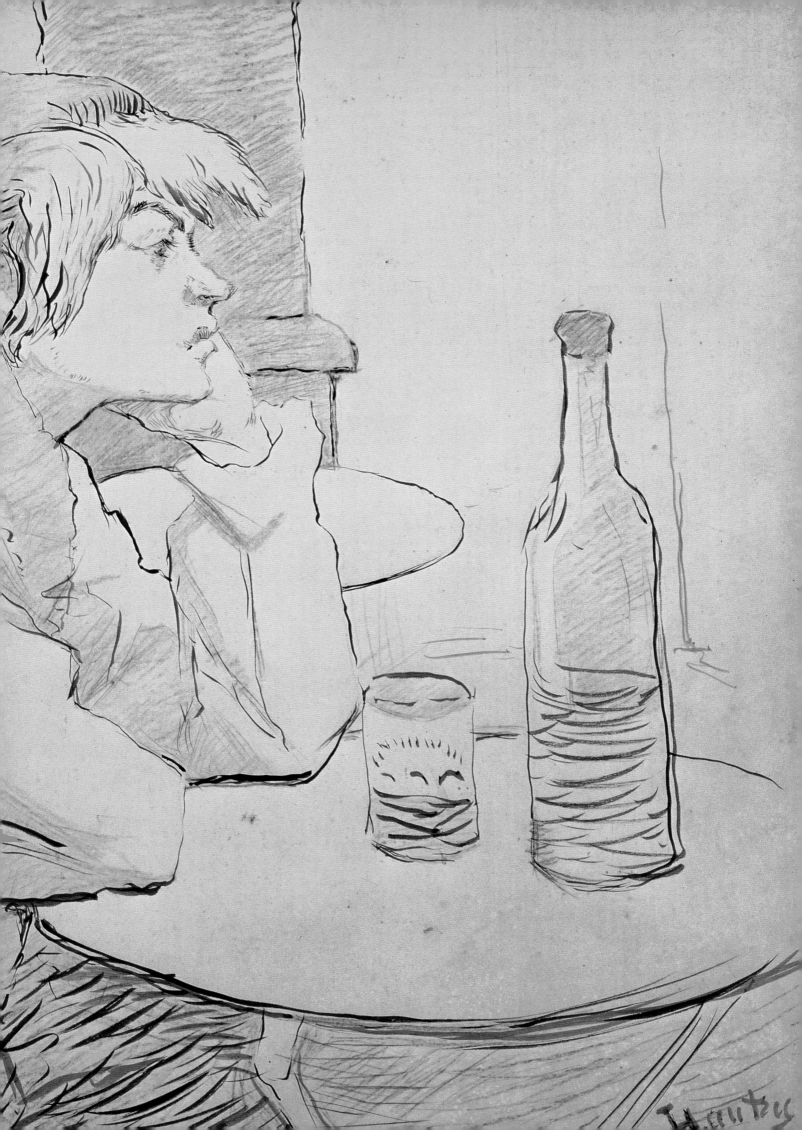

called *la voltige à la Richard*, a jump over or through an obstacle, in this case, the paper hoop held out by the clown. Despite the success of the work, Lautrec did not attempt or exhibit any more circus subjects until much later in his career.

According to Joyant, the *écuyère* was posed by the painter, Suzanne Valadon, who was introduced to

Lautrec by the Italian painter Federigo Zandomeneghi. The ensuing love affair between Lautrec and Valadon lasted for nearly two years. Valadon also served as his model for the lonely alcoholic portrayed in *The Hangover (Geule de Bois)*; and for *Study for "The Laundress,"* in which a young, working class woman carries a heavy laundry basket across the street. Both works are genre studies. Such renderings became characteristic of Lautrec's work. Even his portraits of individuals depicted the sitters as exemplars of a certain social type.

The Dance Halls

This effect is fully developed in his series of paintings of Montmartre's dance halls. The *quartier's* dance halls were becoming notorious throughout Paris for the performance of the *chahut*—a popular, riotous dance. Lautrec's achievement in depicting the performers, prostitutes, and night hawks of the dance halls can be seen in his large, multifigured paintings of the *Moulin de la Galette* and *At the Moulin Rouge: The Dance*. Both paintings were successfully exhibited at the Salons des Indépendants, and became the basis for a period of intense artistic activity devoted to the dance halls of Montmartre. When Lautrec produced his first poster for the Moulin Rouge featuring the dancer known as La Goulue, he became known to an even larger audience.

The portrayal of Montmartre's night life was not Lautrec's invention. Other artists—Théophile Steinlen was the best known among them—worked with the same subject matter, mainly as illustrators for newspapers and magazines. Lautrec focused on the crowd, not the site. He immersed himself—body and spirit—in Montmartre's famous and infamous cafés and clubs, achieving a coherent style which was captivating, provocative, and convincing.

Paris's dance halls had existed for at least half a century, but in the early 1880s they were in a state of critical decline, and many establishments had closed their doors. The revival of the *chahut*, an older dance form, in Charles Zidler's Jardin de Paris, turned Montmartre's entertainment industry around. New

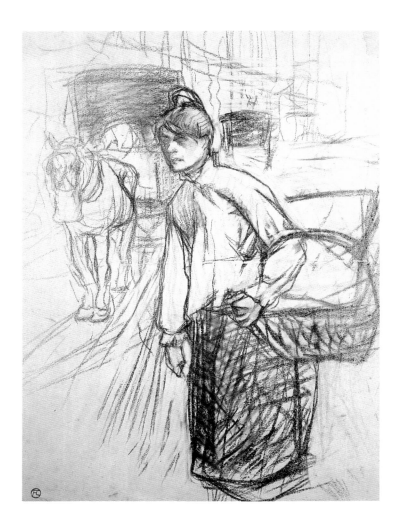

Study for *The Laundress*

1888, charcoal and stump on paper; 25 1/4 x 19 1/2 in. (65 x 50 cm). Musée Toulouse-Lautrec, Albi.

The rapidly executed study for a laundress on a Parisian street belongs to a series of similar subjects which were probably done in the artist's studio. Depictions of young laundresses usually contained sexual connotations, none are apparent in this study for which Suzanne Valadon appears to have posed.

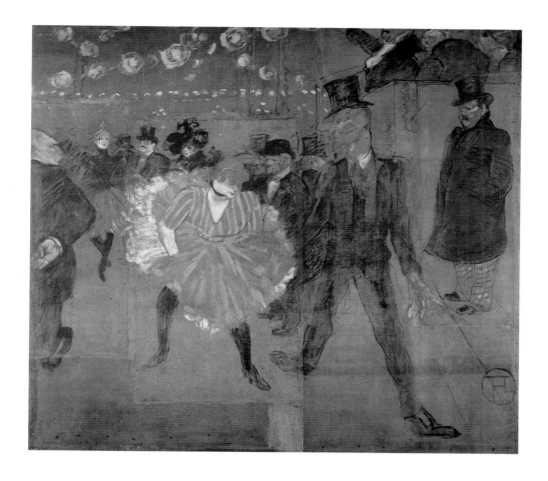

**Dancing at the
Moulin Rouge:
La Goulue and
Valentin le Désossé**
1895, oil on canvas;
116 x 123 1/4 in.
(298 x 316 cm).
Musée d'Orsay, Paris.
When La Goulue's fortunes
waned, she opened a fair-
ground where she performed
belly-dancing. She asked
Lautrec to paint two panels
for the stall to be placed
on either side of the entrance,
of which this is the first
(the second panel illustrated
a Moorish dance).

life was given to the dance halls, and impresarios such as Zidler encouraged artists to represent the popular phenomenon. Professional dancers were encouraged to mix with the crowds, and present occasional solo performances. These spectacles soon became institutionalized and were staged nightly, attracting crowds of curious and bemused spectators. Some came only to see the performers with outrageous stage names such as Grille d'Egout ("Drain Cover"), La Môme Fromage ("Mistress Cheese"), and, above all, La Goulue ("The Glutton").

Lautrec's first large-scale painting, *At the Moulin de la Galette* (1889), captured the crowds at the scene. In the foreground, on a diagonally receding bench, are the portraits of three women and a man. The crowd, comprised of differing classes and professions, dances and socializes in the background. The critic Félix Fénéon described the painting:

The pretty profile of a young prostitute in a smart collar, mischievous eyes and a little clouded by alcohol; another profile, sowlike; the angular head of Alphonse [slang for a pimp], a man of "standards"; the abrupt vertical of two little dancing Pellegrins [reference to a theater play]; the skating movements of a dancer like a wading bird; and the policeman who feebly rebukes a young man of icy mien, hands plunged into his ulster and collar turned up to meet his cap.

The man in the bowler hat was actually the painter Joseph Albert, a friend of Lautrec's, and the painting's first owner. This depiction of the last rustic dance-hall in Paris, located on the top of the Montmartre hill, is quite different from Auguste Renoir's romantic vision of the *Ball at the Moulin de la Galette* (1876). In a little more than ten years, the charm of Impressionism had given way to a naturalistic, almost cynical point-of-view.

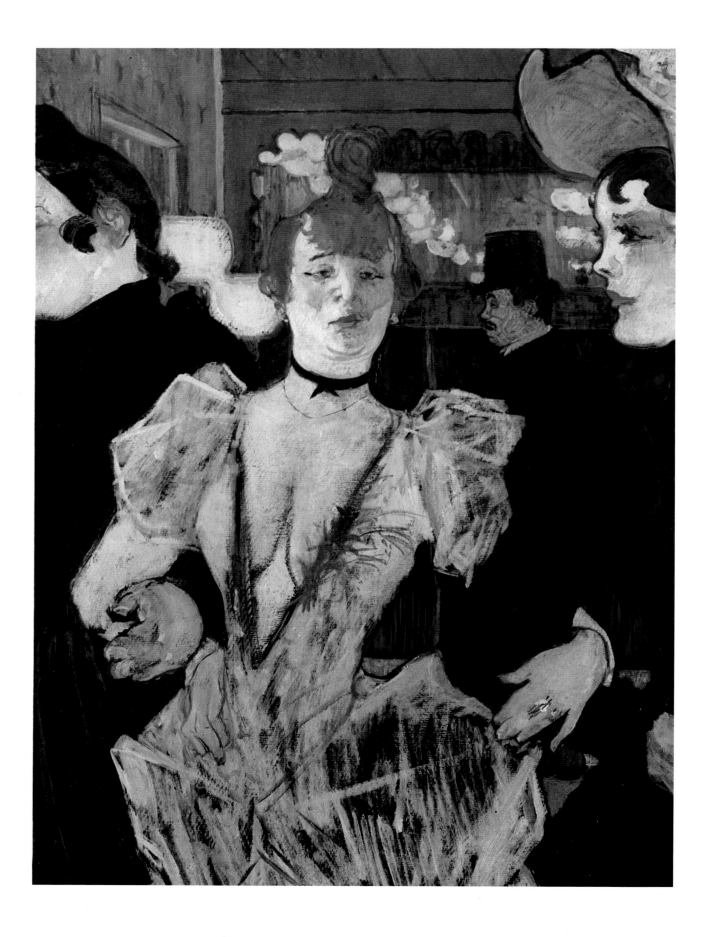

The Moulin Rouge

On October 5, 1889, the Moulin Rouge opened on the Place Blanche on the site of the former, humble dance hall, the Reine Blanche. Two entrepreneurs, Charles Zidler and Joseph Oller, were convinced that money could be made in this part of town, away from the city center. Their instincts proved to be right. The Moulin Rouge became the most popular of all Montmartre's attractions. It was an entertainment factory that offered customers a variety of diversions from spectacles and dances to merry-go-rounds and shooting galleries. The garden of the Moulin Rouge could hold more than six hundred people, and it was dominated by the giant papier-mâché elephant salvaged from the 1889 World Fair. A wooden windmill with red arms, designed by the decorator Léon-Adolphe Willette, crowned the site and provided the name for this establishment.

All of Paris as well as throngs of visitors from across Europe were drawn to the Moulin Rouge. The clientele was mainly middle-class, but members of royal and aristocratic families also came to watch, dance, and be entertained by performers as various as the establishment's clientele. Among them was the international cabaret star, Le Pétomane, whose many talents included the remarkable ability to make "music" with air emanating from his behind! The real

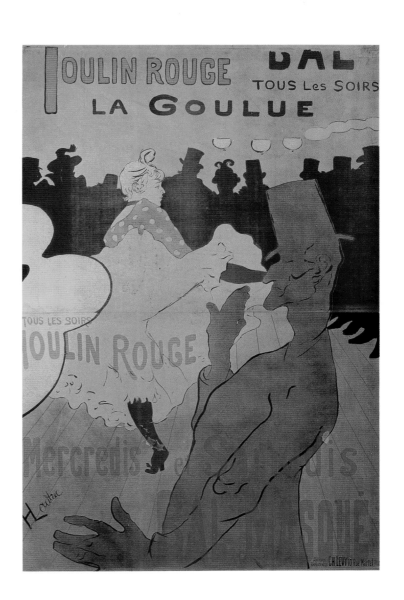

La Goulue Entering the Moulin Rouge

1891–1892, oil on cardboard; 31 x 23 in. (79.4 x 59 cm).
Gift of Mrs. David M. Levy, The Museum of Modern Art, New York.
After his stunning success with his poster *Moulin Rouge—La Goulue*, Lautrec focused on a group of dance hall scenes. The artist valued this particular painting very highly. It was exhibited no less than four times within a year after its completion.

Moulin Rouge—La Goulue

1891, lithograph; (192 x 122 cm). Musée Toulouse-Lautrec, Albi.
La Goulue was one of Lautrec's major subjects at the height of his artistic powers. Born in Lorraine in 1866 as Louise Weber, the working class girl became one of the most celebrated dance hall performers of her time. The poster was critically praised and included in various exhibitions.

attraction at the Moulin Rouge was the enticing mixture of flamboyant spectacle, equivocal female company, and artistic Bohemia. It became one of Lautrec's favorite haunts.

One of the greatest stars at the Moulin Rouge was Louise Weber (1870–1929), a native of Alsace who became famous as the dancer, La Goulue. She had invented as her own act the "naturalist quadrille," a variation on the famous cancan. Her signature on these performances was to extend her leg, hold her foot above her head, and then end each performance with splits and an ear-splitting shriek. For the next several years she was one of Lautrec's favorite models together with her dance partner Valentin (Etienne Renaudin, 1843–1907), nicknamed "the Boneless" or "Double-Jointed" because of his extraordinary flexibility.

"Training of the New Girls"

In *Training of the New Girls, by Valentin "the Boneless" (Moulin Rouge)* Lautrec depicted a public rehearsal. La Goulue dances in the center of the floor. Her vibrant legs in bright red stockings immediately catch the viewer's attention. Her partner, Valentin, is less prominent. His slender top-hatted figure forms a peculiar contrast to La Goulue's boisterous presence. Among the bystanders, Lautrec painted several of his friends. The woman in the foreground in the pink dress and large hat is an ambiguous figure. Is she an adventurous member of the middle-class or well-dressed prostitute? It was not always clear who was respectable and who was not at the Moulin Rouge. Lautrec heightens the naturalistic effect of the painting by cutting off some figures in the foreground. The spectator is drawn into the depicted scene, and seems to stand at the edge of the dance hall.

After the painting had been exhibited at the Salon des Indépendants, it was bought for the Moulin Rouge where it hung in the foyer above the bar with Lautrec's *Equestrienne (At the Circus Fernando)*. Although Lautrec had not intended to paint a decorative image, he was delighted to see his work prominently displayed. He agreed to the sale without hesitation.

The success of *Training of the New Girls, by Valentin "the Boneless" (Moulin Rouge)* and the Zidler's satisfaction with the painting earned Lautrec a commission for his first poster. In *Moulin Rouge—La Goulue*, Lautrec washes the dancer in light and captures the vigor of her dance against the black line of bystanders that form a line of shadow puppets. Valentin appears as a faded silhouette in the foreground. The artist's use of color and silhouette shows the influence of Japanese prints, which were highly popular at the time. The simplified, strikingly, modern image was easy to read and its direct appeal immediately caught the eye.

Lautrec's poster caused a sensation, and could soon be seen all over Paris,and the work put him in the public eye. The artist himself considered the poster worthy enough to include in several of his exhibitions in 1892. His reputation was now established.

Training of the New Girls by Valentin "the Boneless" (Moulin-Rouge)

detail; 1889–1890, oil on canvas. The Henry P. McIlhenny Collection in Memory of Frances P. McIlhenny, Philadelphia Museum of Art, Philadelphia.
Several sharp accents of a surprisingly bright scarlet in the dancer's stockings and the jacket of the androgynous figure to the left add a lively note to the scene that is complemented by the light brown overcoats of the dancer Valentin and various bystanders.

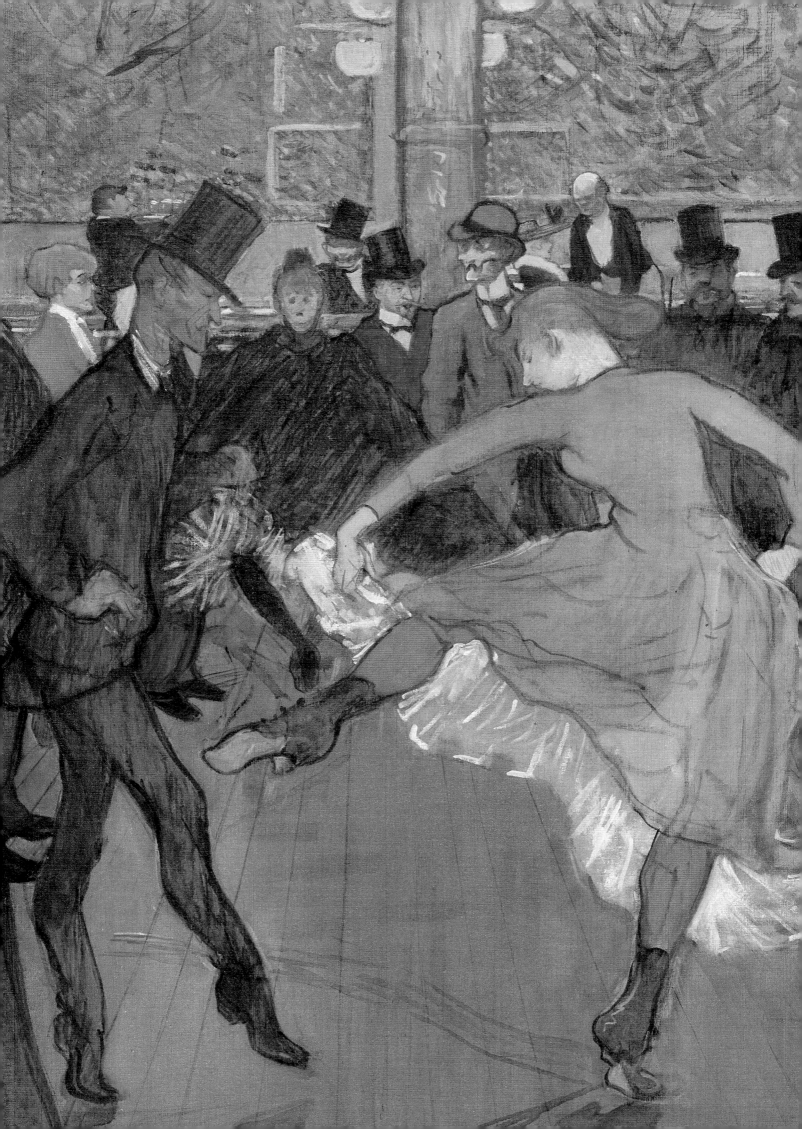

The Young Routy

c. 1883, oil on canvas; 25 1/2 x 19 in. (65 x 48.8 cm). Neue
Pinakothek, Bayerische Staatsgemaeldesammlungen, Munich.
The farm boy, who worked on the estate at Céleyran,
was one of Lautrec's favorite models. Both were nearly
the same age and Lautrec must have felt a certain
attraction to "this short, sturdy countryman with his
lively and yet seemingly reserved expression." Out of a
total of eleven studies, probably executed during the
summer of 1893, this work appears to have been the last.

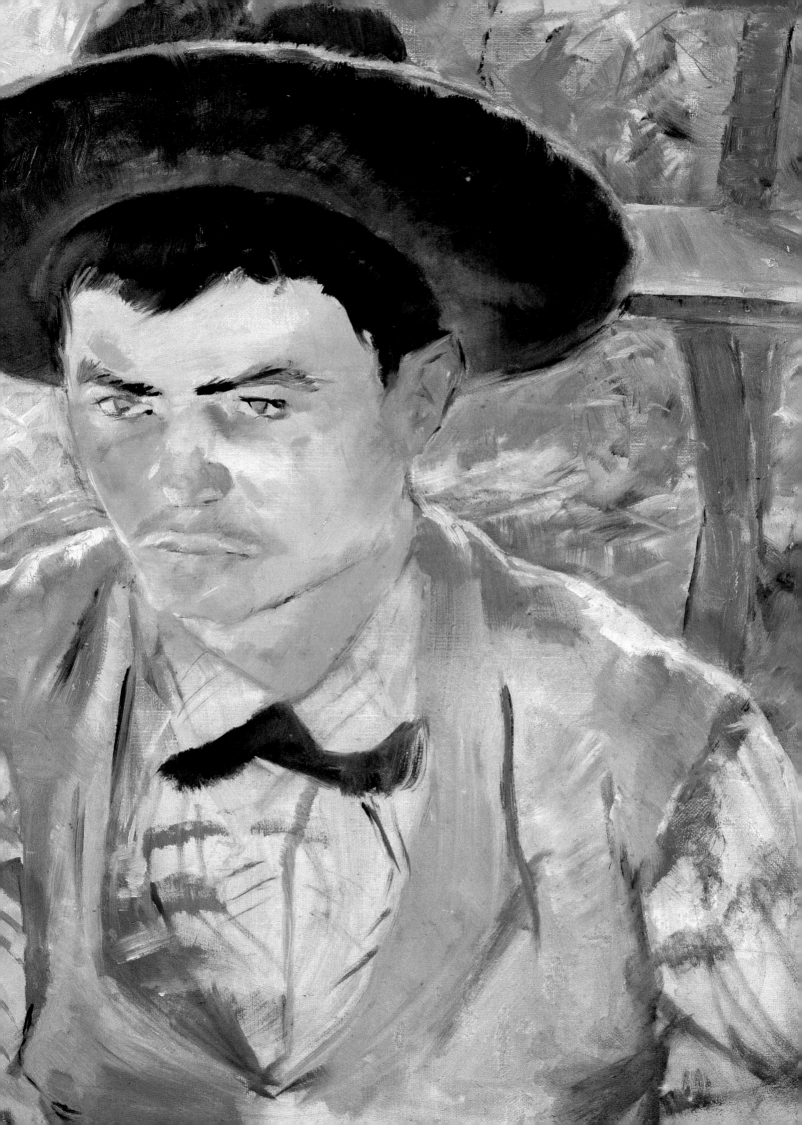

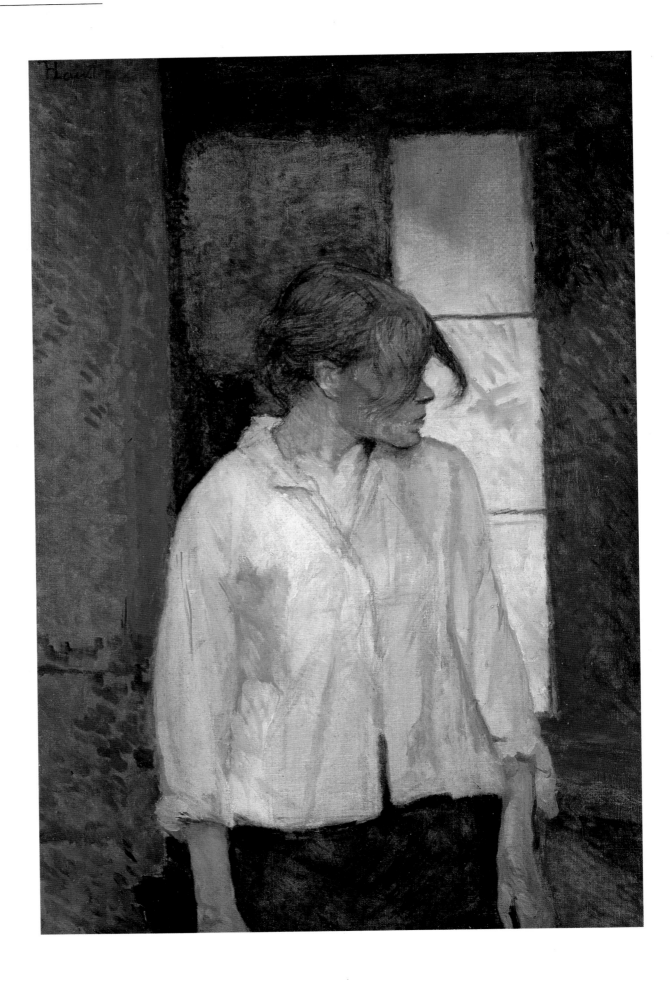

Self-Portrait Caricature

1855, pen and ink;
12 x 5 in. (30.4 x 12.7 cm).
Musée Toulouse-Lautrec, Albi.
While serious self-portraits
by Lautrec are rare, the artist
frequently caricatured himself.
In the present drawing he
appears to be dressed as an
animal tamer with a long
frock coat and a whip, his
bespectacled canine face gazing
toward an unknown being.

At Montrouge (Rosa La Rouge)

1886–1887, oil on canvas; 28 1/2 x 19 1/4 in. (72.3 x 49 cm). The Barnes Foundation, Merion, Pennsylvania.
The model's red hair and red lips set off the rather dark, Rembrandtesque palette. The concentration
on her jaw is enhanced by the light. Rosa La Rouge is representative of the provocative, young,
working class woman with extraordinary hair whom Lautrec would paint over and over again.

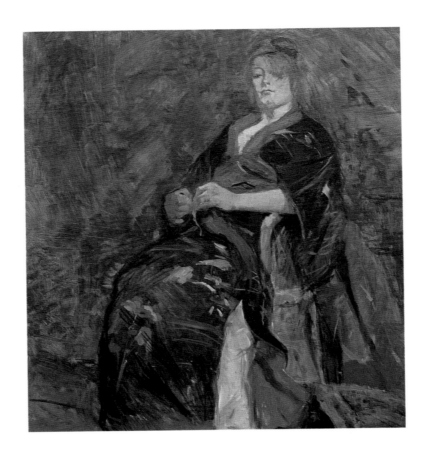

Mme. Lili Grenier

1888, oil on canvas; 21 1/2 x 17 3/4 in. (55.3 x 45.7 cm).

The William S. Paley Collection, The Museum of Modern Art, New York.

Lili Grenier was the wife of the painter, René Grenier, who shared Lautrec's studio. "Lili, with her flaming hair, the fierce line of her jaw, her milky complexion with its minute red freckles, was most desirable, and formed the center of a group of admirers who hoped for some private success by dint of paying homage."—FRANÇOIS GAUZI *My Friend Toulouse-Lautrec*

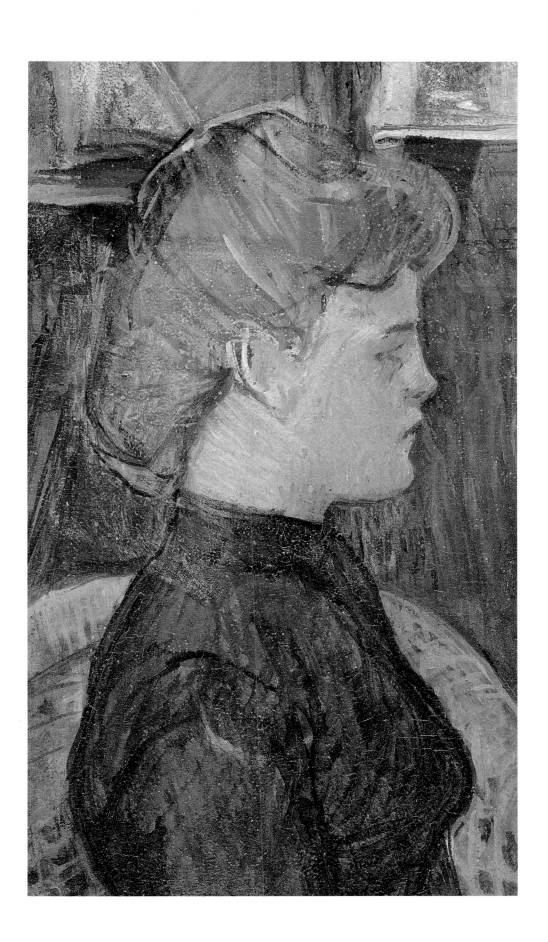

The Painter's Model Hélène Vary in the Studio

1889, oil on cardboard; 13 1/2 x 7 1/2 in. (34.8 x 19.5 cm). Musée Toulouse-Lautrec, Albi. Lautrec's neighbor in Montmartre, Hélène Vary, was "extremely beautiful, admirable!" according to the artist. "Her Grecian profile is incomparable!" he confided to his friend François Gauzi. The purity of her profile and her elegant posture seem to confirm the impression of a determined, noble character.

Chocolat Dancing in Achille's Bar

*1896, brush with black ink, blue pencil, and
charcoal, heightened with white; 25 1/4 x 19 1/2 in.
(65 x 50 cm). Musée Toulouse-Lautrec, Albi.*
Chocolat was a popular clown at the Nouveau Cirque.
Here, he performs an improvised dance at Achille's Bar,
a popular after hours gathering place. The comical,
exaggerated pose also captures the dancer's lithe grace.

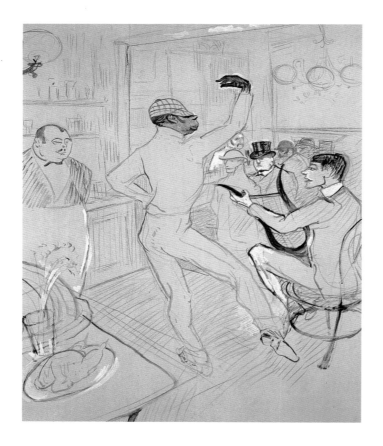

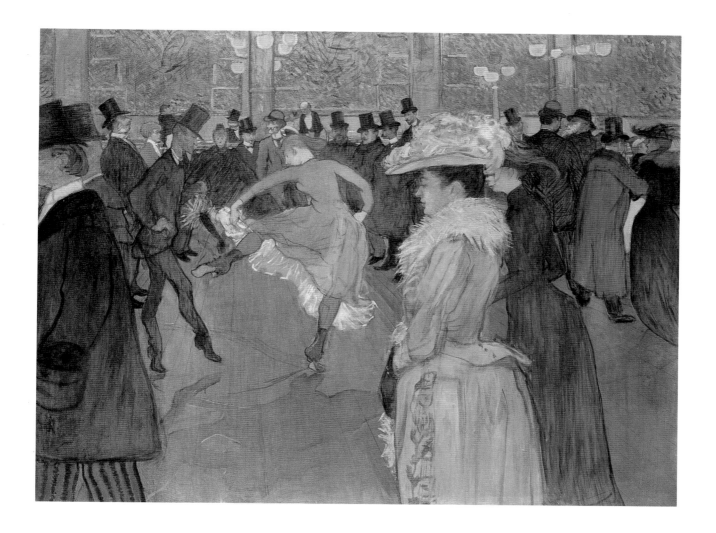

Training of the New Girls by Valentin "the Boneless" (Moulin Rouge)

1889–1890, oil on canvas; 44 7/8 x 58 1/2 in. (115 x 150 cm). The Henry P. McIlhenny
Collection in Memory of Frances P. McIlhenny, Philadelphia Museum of Art, Philadelphia.
Lautrec draws the observer to the very edge of the dance floor with his dynamic use
of color and light. He adroitly contrasts the movement of the dancers with the motionless
line of spectators, and places an ambiguous well-dressed man in the foreground.

**Comtesse Adèle-Zoé
de Toulouse-Lautrec,
the Artist's Mother**

*detail; c. 1883, oil on canvas.
Musée Toulouse-Lautrec, Albi.*
Smooth brushstrokes model
the white surface of the
porcelain, while the hands
and the table are rendered
with stronger strokes. The
china cup and the woman's
hands are symmetrically
reflected on the shiny surface
of the table, and the composi-
tion's colors and simplicity
recall the still-life paintings
of Jean Baptiste Chardin.

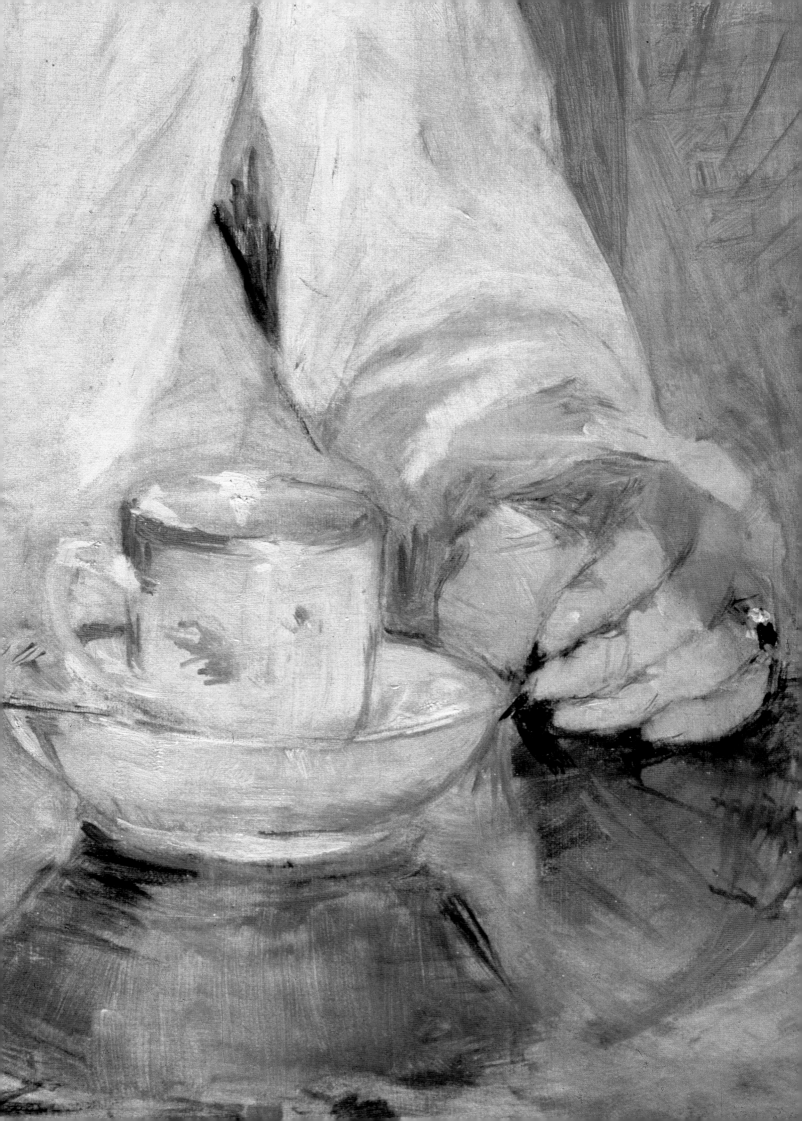

The Toilette

1900, oil on board; 23 3/4 x 19 1/3 in.
(60.8 x 49.6 cm). Musée Toulouse-Lautrec, Albi.
The influence of Edgar Degas can clearly be felt in this
painting. Sitting before a mirror at her dressing table the
woman is motionless. Her face is almost completely hidden
by her long reddish hair. The dark, somber colors—brown
and a dark green predominate—convey a rather bleak mood.

The Jockey

1899, lithograph; 20 1/4 x 14 1/2 in.
(52 x 37 cm). Victoria and
Albert Museum, London.
Returning to his early interest
in horses, Lautrec produced
several prints of horse races.
With admirable virtuosity the artist
conveys the enormous power and
speed of the horses. The windmill
at the right indicates the location
as the racetrack at Longchamp.

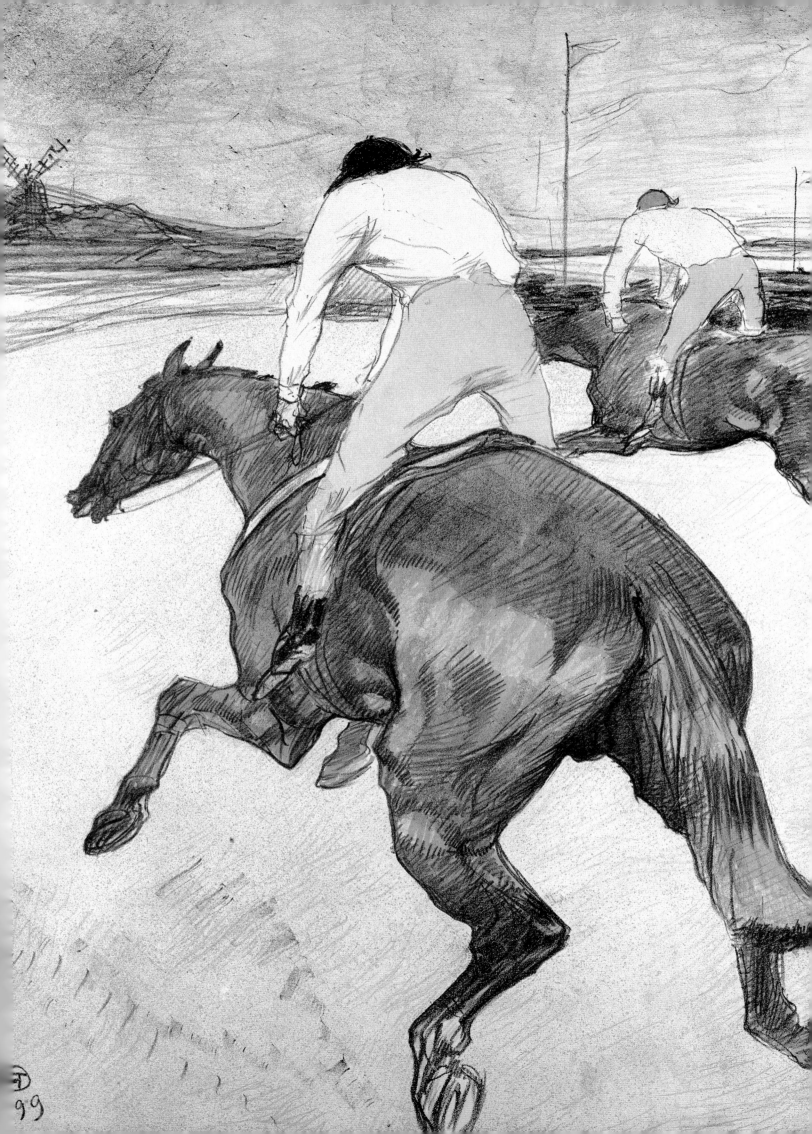

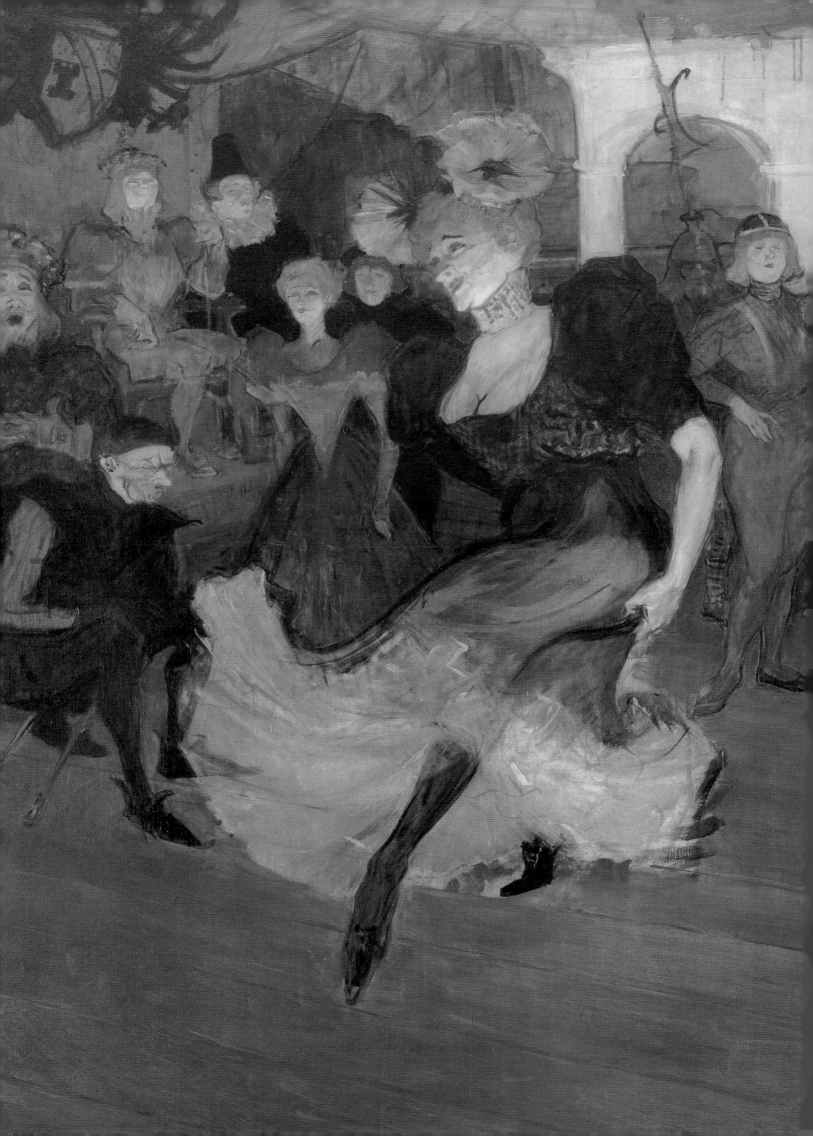

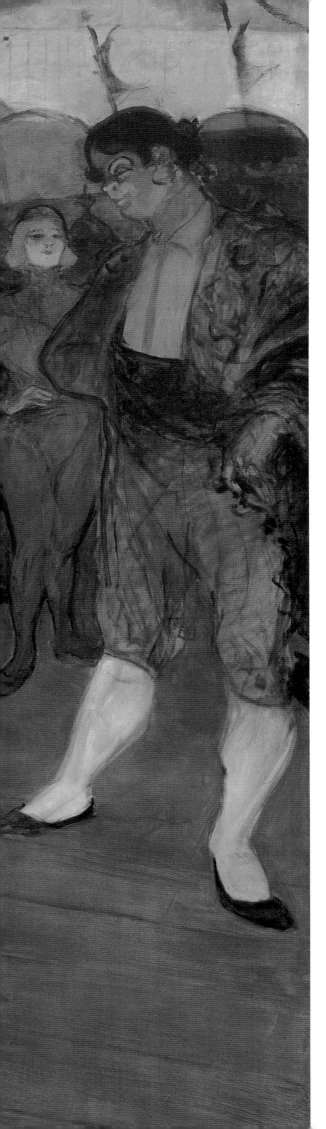

THE WORLD OF THE PERFORMING ARTS

Lautrec maintained a lifelong interest in the performing arts. Dance, theater, opera, cabaret, and the circus were all of equal interest to him. He was more intrigued by their diverse appearance and dazzling visual presentation than he was fascinated by their individual nature. "All plays are the same to me," he reportedly said. He could attend some twenty performances of the operetta *Chilpéric*, and each time he was captivated anew by the glitter and exuberance of the performers, the mysterious stage light, and Marcelle Lender's famous performance of the bolero.

At the Theater and the Cabaret

At other times, he was merely interested in rendering theater goers as in his *Study for "La Grande Loge."* Theater balconies had already been the subject of paintings by Edgar Degas and the American painter, Mary Cassatt. For all three artists, the box was a stage in itself where intimate dramas unfolded. Here, two elegant women are exposed to the audience, as if they were on stage. In *The Theater Box with the Gilded Mask*, which was made to illustrate a theater program, an elegant woman surveys the stage and the spectators below her. We can just barely see the profile of her male

Marcelle Lender Dancing the Bolero in *Chilpéric*

1896, oil on canvas; 56 1/2 x 58 1/2 in. (145 x 150 cm). Gift (partial and promised) of Betsey Cushing Whitney in honor of John Hay Whitney, for the Fiftieth Anniversary of the National Gallery of Art, The National Gallery of Art, Washington, D.C.
Lautrec admired and enjoyed Marcelle Lender's (1862–1926) performance of the bolero. He rendered the linear curves and movements of her body with quick, fluid brushstrokes. The figures of the other performers idling in the background are rendered with a smoother surface and cooler tones.

companion, who has the features of the Australian painter Charles Conder. The simple but effective contrast of the red interior of the box and the woman's black dress as well as the reduced decorative elements enhance the impact of the design.

Another star of the Moulin Rouge would attract Lautrec's attention: Her name was Jane Avril, and she became one of Lautrec's most characteristic figures. Known as *La Mélinite* (a type of explosive similar to dynamite), Avril was hailed by critics as "the incarnation of dance." Lautrec and Avril developed a close friendship and genuine liking for each other, and she soon became one of the artist's favorite models. The dancer's somewhat sickly appearance belied her tremendous energy. Lautrec depicted her onstage and off in *Jane Avril Dancing*, *Jane Avril Entering the Moulin Rouge*, and caught her in unassuming moments, as in *Jane Avril, Back View*. Lautrec, like his father, loved to dress up in various disguises; he once posed for a photograph wearing Avril's feathered hat, cloak, and feather boa.

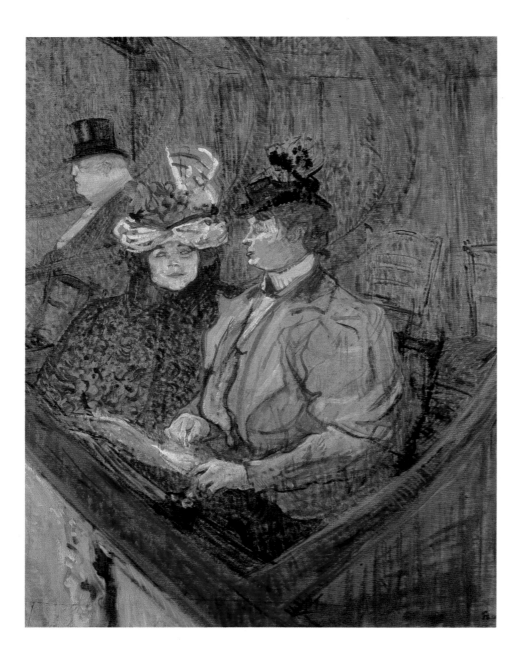

Study for *La Grande Loge*
1896, oil and gouache on cardboard;
21 1/2 x 18 1/2 in. (55.5 x 47.5 cm).
Private collection, Zurich.
The figures in this study, made in preparation for a lithograph, can be identified from left to right: Tom, the Rothchild coachman, depicted as a brute; the actress and dancer Emilienne d'Alençon; and Madame Armande, owner of the brasserie Le Hanneton, one of the Parisian meeting places for lesbians.

The Theater Box with the Gilded Mask
1893, oil on canvas;
16 x 12 1/2 in. (40.8 x 32.4 cm).
Musée Toulouse-Lautrec, Albi.
Illustrated theater programs were one of the means by which Lautrec reached a larger public. This painting was the first inspiration for a lithograph Toulouse-Lautrec made to illustrate *Le Missionaire*, a play by Marcel Luguet, at the Théâtre Libre. The economy of artistic means heightens the startling effect of the composition.

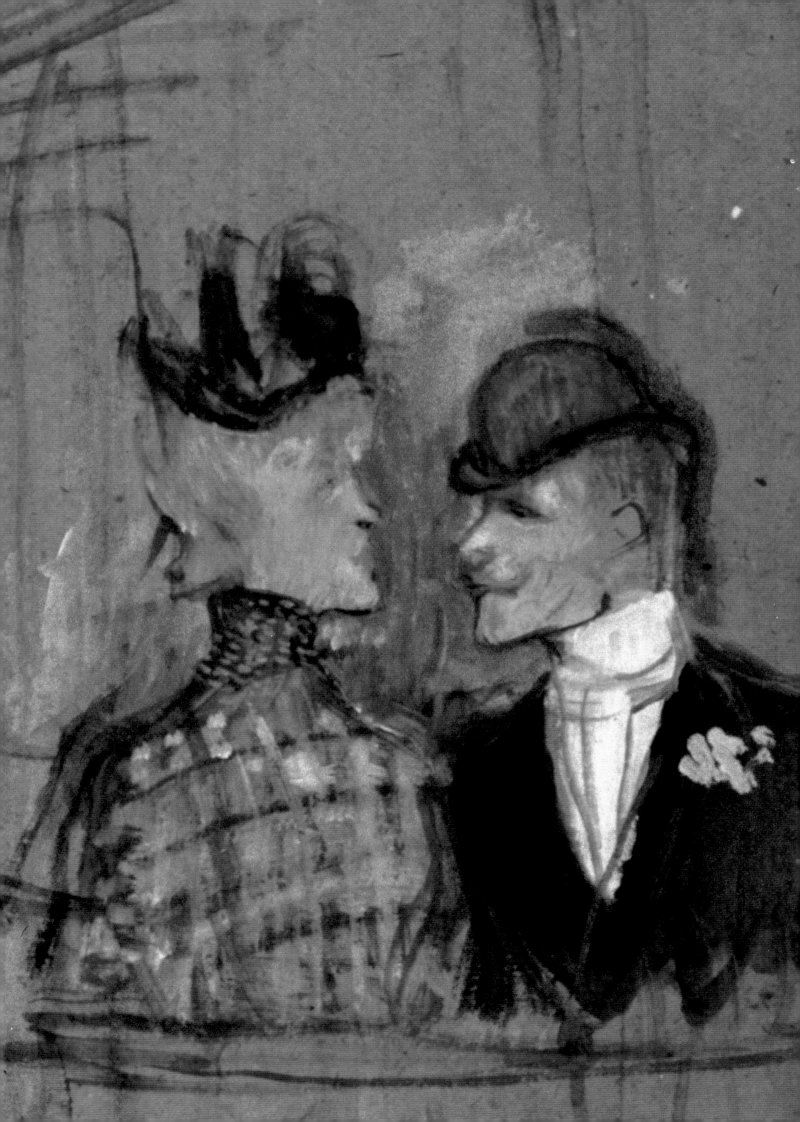

Aristide Bruant

Aristide Bruant (1851–1925), a singer and composer of humble origins, opened his own cabaret in July 1885, called Le Mirliton. Its motto, "Le Mirliton, for Audiences that Enjoy Being Insulted," set the tone for which Bruant became infamous. He attacked his bourgeois clientele with rude songs, written in the vernacular of the working class.

> Ours is the fortune and the glory
> Slaughter the bloated rich
> Set up the Commune
> Of letters and arts.

In a guide book to the nightlife of Paris, Rodolphe Darzens described Bruant as, "Tall, with a broad barrel chest and a Napoleonic profile; but his eye is sly and his lip sardonic. He wears sweeping velvet garments, heavy boots and, when he goes out, a long Inverness cape and an immensely wide-brimmed hat."

In 1892, Bruant asked Lautrec to design a poster for his new show at Les Ambassadeurs, a *café-concert* on the Champs-Elysées. Lautrec made an icon of Bruant, using the singer's impressive appearance and characteristic dress. Simplifying and synthesizing the design, Lautrec achieved a powerful language of utmost directness. The manager of the Théâtre des Ambassadeurs, Pierre Ducarre, did not like the poster, but Bruant threatened to cancel his engagement if Lautrec's poster was not displayed. It was. The image immortalized the singer and was later acclaimed as one of the masterpieces of its genre.

Jane Avril Dancing

detail; 1891; oil on cardboard. Musée d'Orsay, Paris.
The figures of this caricatured couple are placed against each other like cutouts pasted onto the cardboard. There appears to be no relationship between them, though—judging from their facial expressions—the man appears to have just made a proposal to the woman.

Les Ambassadeurs: Aristide Bruant

1892, lithograph; 55 x 38 1/4 in. (141.2 x 98.4 cm).
Musée Toulouse-Lautrec, Albi.
In 1892, Aristide Bruant (1851–1925) asked Lautrec to design the poster for Bruant's first performance at the elegant Les Ambassadeurs on the Champs-Elysées. Lautrec depicted the tall, impressive performer in his characteristic outfit —a wide brimmed hat, a large cap and a bright red muffler.

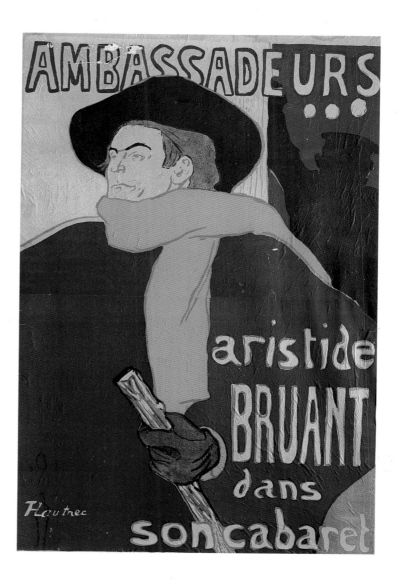

Loïe Fuller

Lautrec discovered Loïe Fuller (Marie-Louise Fuller, 1862–1928) at the Folies-Bergère in 1892. The American-born dancer from Illinois had given up a successful career in opera and vaudeville to devote her talents exclusively to dance. Swirling her layered muslin costume, lit by multicolored stage lights which she designed and patented, the dancer dazzled audiences with her original choreography and visual effects. Her performances were the manifestation of "symbolist" dance. In her memoirs Fuller described a performance:

Loïe Fuller at the Folies-Bergère

1893, oil on cardboard; 24 1/2 x 17 1/2 in.
(63.2 x 45.3 cm). Musée Toulouse-Lautrec, Albi.
In preparation for a set of lithographs, Lautrec
made this study of the American-born dancer,
Loïe Fuller, capturing the iridescent flame-
like swirl of her dress of layered muslin voile.

My dress was so long that I was always treading on it, and so, automatically, I held it up with both hands and lifted my arms in the air as I continued to flit all over the stage like a winged sprite. A cry went up from the auditorium: "A butterfly!" I started to whirl round while running from one end of the stage to the other, and there was a second cry: "An orchid!"

Lautrec himself was reminded of the Victory of Samothrace, the monumental winged sculpture in the Louvre. In his rendering of *Loïe Fuller at the Folies-Bergère*, a preparatory study for a lithograph, Lautrec achieved a surprising level of lyrical abstraction which corresponded to Fuller's performance. Edmond de Goncourt remembered her dance as "a cyclone of veils and a swirl of skirts, illuminated now by the conflagration of a setting sun, now by the pallor of a sunrise."

The lithograph of *Loïe Fuller*, of which each impression was hand-colored individually, is one of Lautrec's most finished works. The controlled sensations of different combinations of colors were heightened in some of the impressions by adding a sprinkling of gold powder evoking the luminous quality of Japanese prints. The result was a visual equivalent of Fuller's dance. Nevertheless, Lautrec did not obtain the dancer's approval to design her posters.

Yvette Guilbert

The fame of the *diseuse* Yvette Guilbert (1867–1944) was intimately linked to Lautrec's own success. Her tall, slim silhouette, satin dresses with low necklines, and long black gloves were immortalized by various painters. None achieved the directness and expressiveness of Lautrec's renderings. Guilbert's career had started slowly. She first worked as a fashion model and then as a salesperson in a department store. She made her debut at the Bouffes du Nord, appearing in Alexandre Dumas' *La Reine Margot*, and eventually became a solo cabaret performer. Guilbert recalled her period of apprenticeship in her biography:

Every rehearsal taught me a lot, and it was watching the practice of "dramatic art" that taught me to sing! It was those actors who influenced my style; later, when I had to learn a song, I set myself to *act* it.

From 1890 on, Guilbert appeared at the Moulin Rouge, the Divan Japonais, Les Ambassadeurs, and the Folies-Bergère. Triumphant tours in Europe and the United States made her a world-renowned performance artist.

Lautrec made numerous sketches and drawings of Guilbert and produced an album of sixteen lithographs with text by Gustave Geoffrey. *Yvette Guilbert Taking a Curtain Call* is based on a photographic enlargement of the last lithograph of the album. She looks twice her real age of twenty-seven years, and very much like a caricature of a opportunist of the Paris scene. The critic Jean Lorrain described her looks at a performance at Les Ambassadeurs in 1899:

> Dry as a bone, lips like a knife-blade, looking like a bat in an ash-gray dress, Mademoiselle Guilbert announces the idiocy of the *café-concert* and mocks in an acid voice *Les Grosses Dames*; then innocently renders, for the nine-hundred-and-ninety-ninth time, Monsieur Maurice Donnay's *Eros vanné* [Knackered Cupid], which the audience applauds wildly, grateful to the artist for the sincerity of her repertoire and the conscious nature of her choice.

Yvette Guilbert Singing "Linger, Longer, Loo" was also used in Lautrec's Guilbert album. It also served as a study for a reproduction in the satirical magazine *Le Rire*. The painting shows Guilbert performing a famous English song of the day. Her body is bent forward in an s-shaped curve. Her pale, smiling, face is lit by stage light below. Her chin rests on her folded hands covered in the long gloves that were her emblem. Only the light and shade of her face have been fully developed. The rest of her figure is rendered with quick, decisive strokes of the brush. The color scheme of dark blue for the outlines of her arms, yellow for her hair, and white for the dress is carefully balanced with other shades of blue and green.

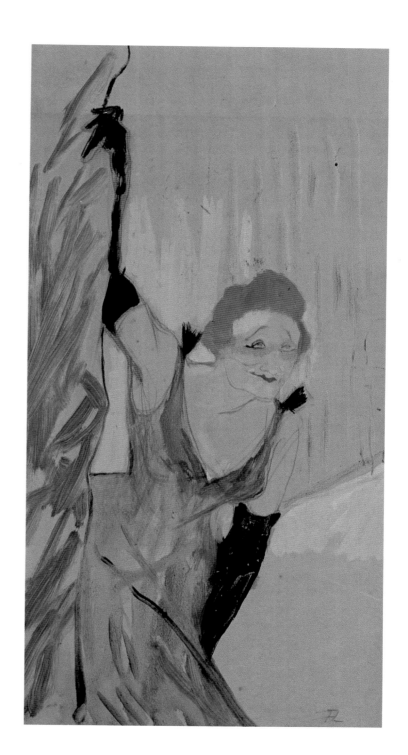

Yvette Guilbert
1894, charcoal heightened with oil on tracing paper;
72 1/2 x 36 1/4 in. (186 x 93 cm). Musée Toulouse-Lautrec, Albi.
Guilbert was famous for her tall and slim silhouette as well as her legendary black gloves. Lautrec exaggerated Guilbert's features, and his subject rejected the unflattering painting which was made in preparation for a poster to advertise the singer's forthcoming season at Les Ambassadeurs.

Yvette Guilbert

1893, gouache and charcoal on paper; 21 1/4 x 14 3/4 in.
(54.5 x 38 cm). Fundaciòn Colecciòn Thyssen-Bornemisza, Madrid.
Far removed from the conventional feminine ideal, Guilbert
had nevertheless a successful career. In her memoirs, written
in 1927, she defined her personal style: "I wanted above all
to appear highly distinguished, so that I could risk anything."

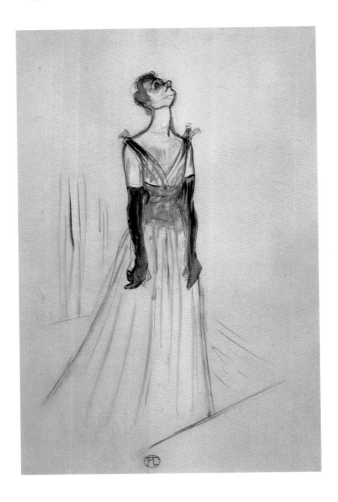

The watercolor of *Yvette Guilbert* was created to
illustrate an article about the singer by Gustave
Geoffrey for *Le Figaro Illustré* in 1893. The star is
shown in the glare of the footlights with her head
thrown back. A similar study was intended for a
poster, which was never executed. Guilbert rejected
the image because she thought it was too unflattering.
The successful singer and monologuist was not with-
out her critics. Edmond de Goncourt wrote in his
Journal for June 28, 1894:

Ended the evening at the Café des Ambassadeurs,
listening to Yvette. She lacks the sheer vulgar grandeur
of Thérésa, but she has a marvelous clarity of diction
and a superior intelligence in handling the detail of a
verse: but her choice of material is deplorable, as far as
words go! I should like to hear her speak some
Baudelaire . . .

Cha-U-Kao

We know little about the female clown Cha-U-
Kao except that she performed at the Moulin Rouge
and the Nouveau Cirque, and if it were not for
Lautrec's paintings of her, Cha-U-Kao may very
well have been forgotten. Her peculiar name is a
phonetic transcription of *chahut-chaos* (hurly-burly).
In *The Clown Cha-U-Kao at the Moulin Rouge*, she is
seen walking across the dance floor in her baggy
black trousers and wide yellow sash arm in arm with
a heavy-set woman, named Gabrielle-la-danseuse—
whom Lautrec had painted some years earlier. Cha-
U-Kao's white hair is put up in a single grotesque,
beribboned tuft. She has turned around as though
something outside the painting's space had caught
her eye. The two women look in opposite direc-
tions, and do not seem to belong together. In the
background, one can make out the bearded profile
of the novelist and playwright Tristan Bernard
(1866–1947) in the company of a woman in a pink-
ish dress. *The Clown Cha-U-Kao, Actress at the Moulin
Rouge* is one of Lautrec's most finished works. It
shows her in her dressing room adjusting her outfit.
The fall of her enormous yellow sash emphasizes the
roundness of her flesh. Her dark blue dress, the yel-
low sash, the red-brown velvet of the sofa and the
greenish walls are a masterful symphony of careful-
ly composed colors.

The Clown Cha-U-Kao

1895, oil on cardboard; 21 x 19 in. (54 x 49 cm). Musée d'Orsay, Paris.
This uncompromising and unflattering portrait of the clown
Cha-U-Kao is one of Lautrec's most finished works. The curious
name of the sitter is a phonetic transcription of "chahut-chaos,"
referring to the riotous dance similar to the cancan.

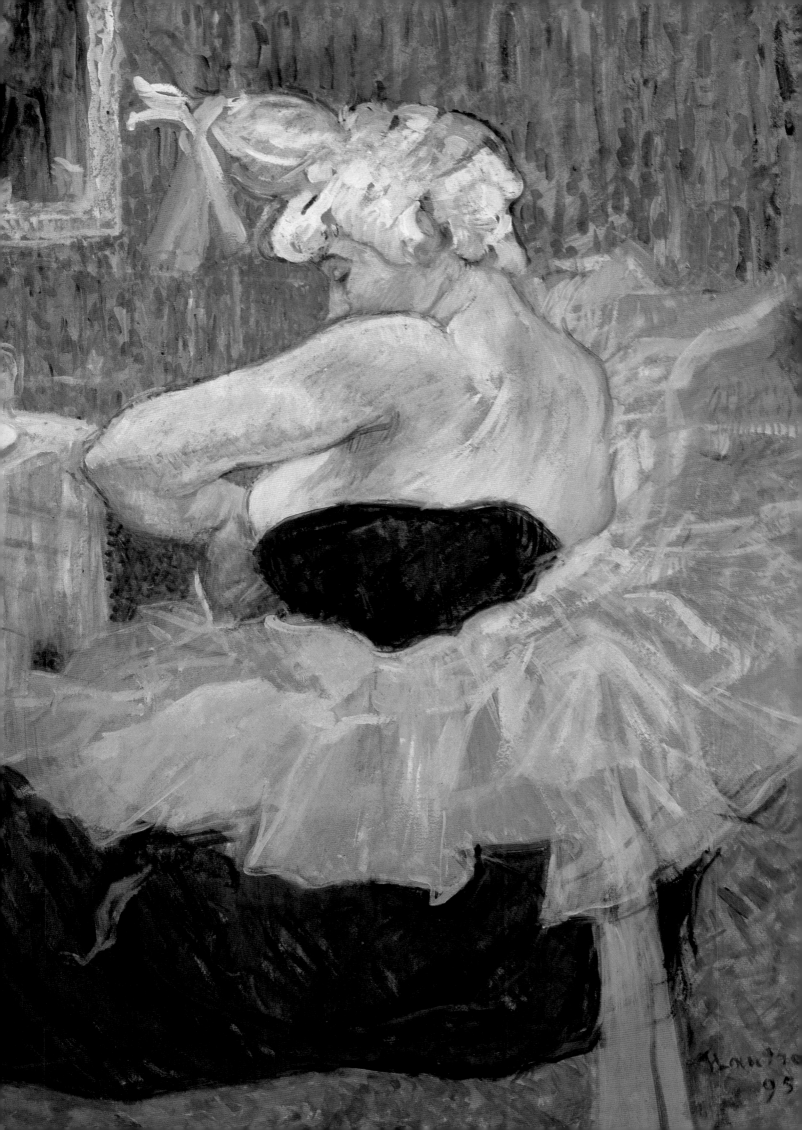

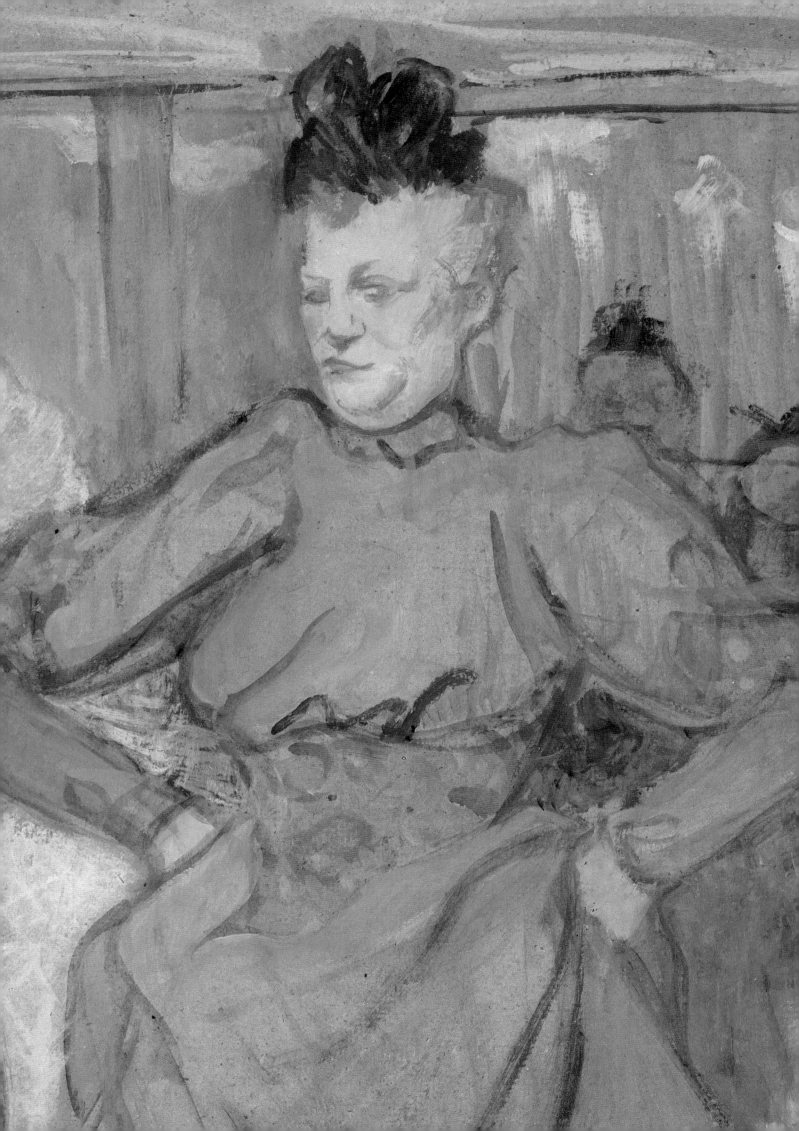

"At the Moulin Rouge"

Henri de Toulouse-Lautrec moved freely among the performance stars of Paris. His friends saw his ". . . eyes eager to see everything, practiced at observations . . ." rather than his misshapen figure. His sharp intellect and sarcastic humor made him an interesting companion, but he could often be shy. *At the Moulin Rouge* shows him with his cousin Gabriel among the theater audience. In this painting, the dividing line between the backstage and the front of the house has disappeared.

The history of this important painting is unclear. We know with some certainty the names of the sitters. According to Joyant, the figures around the table are, from left to right, the author and dandy Edouard Dujardin, La Macarona, Paul Sescau, a photographer and friend of Lautrec's, and the champagne merchant Maurice Guibert. The mask-like face garishly lit by green stagelight has been identified either as "Nelly C." or the singer May Milton. Behind the table, where La Goulue adjusts her hair in a mirror, is the tall figure of Lautrec's cousin, Gabriel Tapié de Céleyran. Lautrec himself can be seen in a bearded, disembodied profile, wearing a bowler hat and lorgnette. Lautrec has created an eerie, almost ghostly quality in this work. No one appears to be talking. There is no eye contact among the sitters and everyone appears to be completely self-preoccupied.

Although obviously intended to be a major painting such as the *Training of the New Girls, by "Valentin the Boneless,"* the work's genesis is obscure. At an undetermined moment an L-shaped strip of canvas, visible to the naked eye, was added at the bottom right, considerably enlarging the size of the canvas. The best

At the Moulin Rouge: The Beginning of the Quadrille

detail; c. 1892, oil on canvas. Chester Dale Collection, The National Gallery of Art, Washington, D.C.
Her arms akimbo, the somewhat recalcitrant dancer seems to be waiting for a sign to start her performance. Her provocative expression and the cynical curl of her lips might be directed towards a possible suitor or client.

William Warrener (Study for *The Englishman at the Moulin Rouge*)

1892, oil on cardboard; 22 1/3 x 17 3/4 in. (57.3 x 45.3 cm). Musée Toulouse-Lautrec, Albi.
William Warrener served as the model for this portrait study, later used in a lithograph which became known as *The Englishman at the Moulin Rouge*. Warrener was an artist in his own right, and a keen admirer of Lautrec's work.

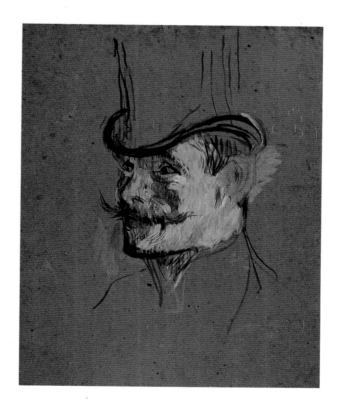

explanation seems that Lautrec intended the multi-figured work to equal the other canvas. The critic Félix Fénéon's remark about Lautrec's fascination with dancers and their male companions accurately describes the atmosphere of *At the Moulin Rouge*:

He admires them, and, studying them with an insistent curiosity, soon hallucinates; he endows with character these dejected, maudlin puppets slipping into senile decay; so the men become ludicrous, the women malevolent—like this one, with a face from the grave, shivering in her furs, her red hair, in which the blood and mud of old lechers would congeal, all disheveled.

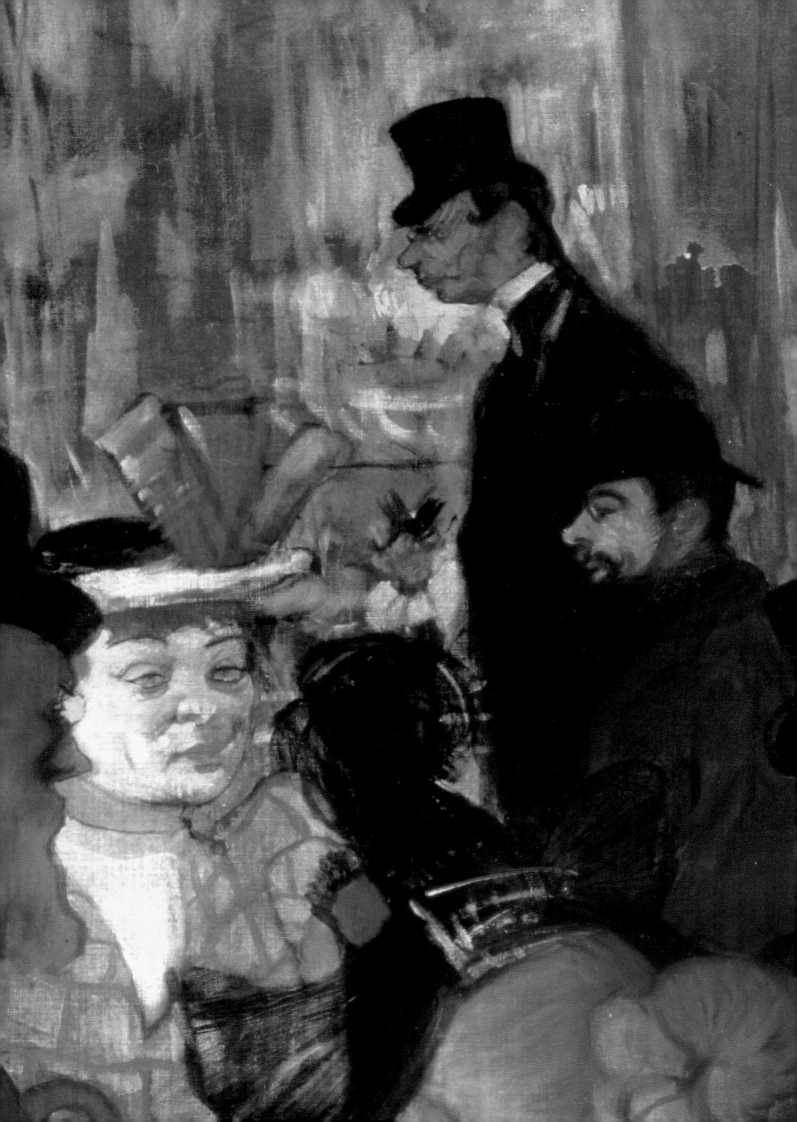

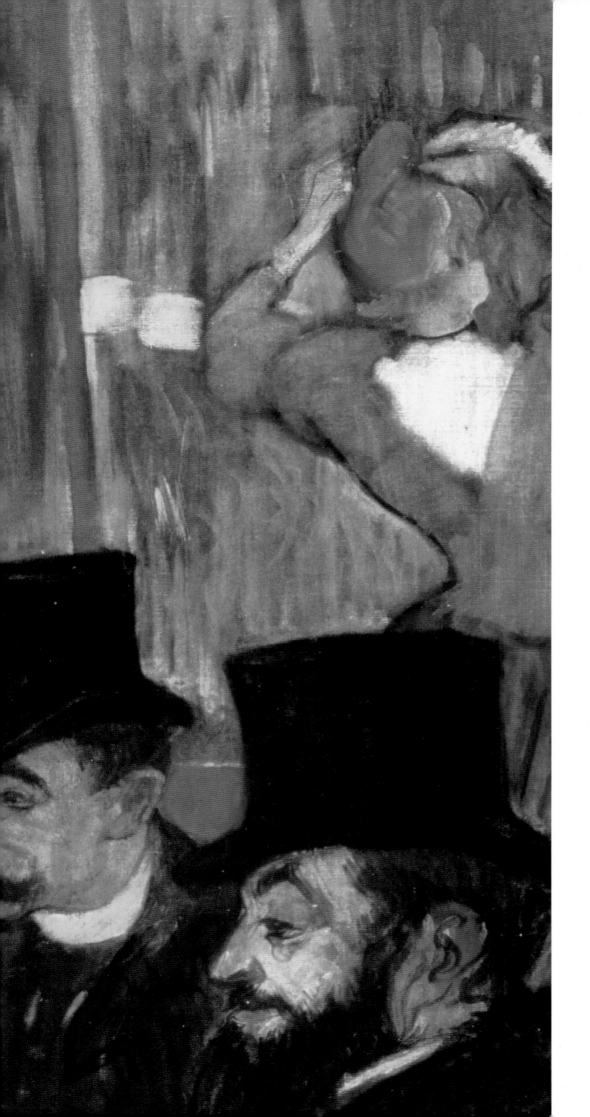

**At the
Moulin Rouge**

*detail; 1892–1893,
oil on canvas. Helen
Birch Bartlett Memorial
Collection, 1928, The Art
Institute of Chicago, Chicago.*
Lautrec and Tapié de
Céleyran walk across the
dance hall of the Moulin
Rouge. The deliberate
contrast between the short,
crippled Lautrec, and his
tall slim cousin is an ironic,
albeit bitter, statement of
the artist's self-deprecation.

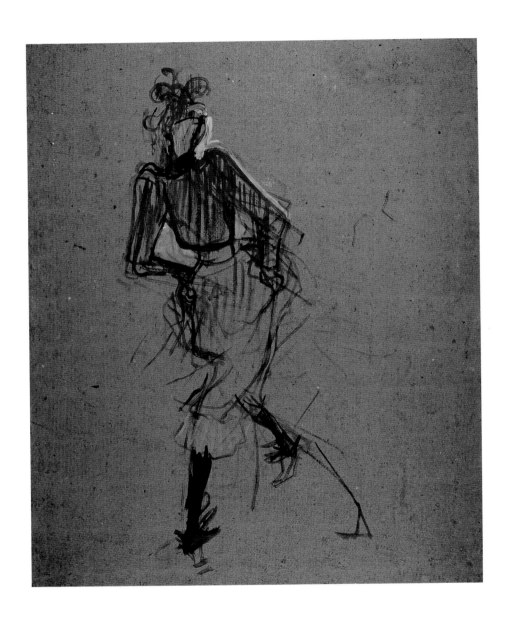

Jane Avril Dancing

c. 1891–1892, oil on cardboard; 33 3/4 x 25 1/4 in. (86.5 x 65 cm). Musée Toulouse-Lautrec, Albi.
Jane Avril is captured in a less energetic pose with both feet on the ground. The twist of
her shoulders indicate the dance's swirling movement. The artist diluted his oil paint
with turpentine to achieve a matte effect, then touched up the image with solid chalk lines.

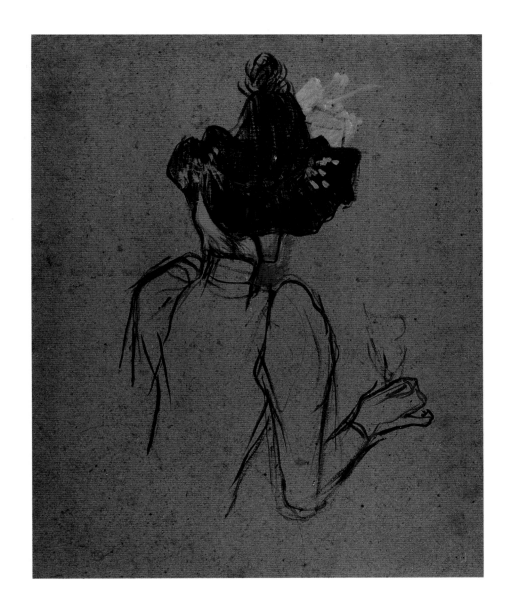

Jane Avril, Back View

c. 1891–1892, oil on cardboard; 26 x 20 1/4 in. (67 x 52 cm). Musée Toulouse-Lautrec, Albi.

In this study, Lautrec focused on a large hat and outlined Avril's body and arms
with a few brushstrokes. She appears to be holding an object in her right hand,
perhaps a flower offered by an admirer at one of the café-concert halls.

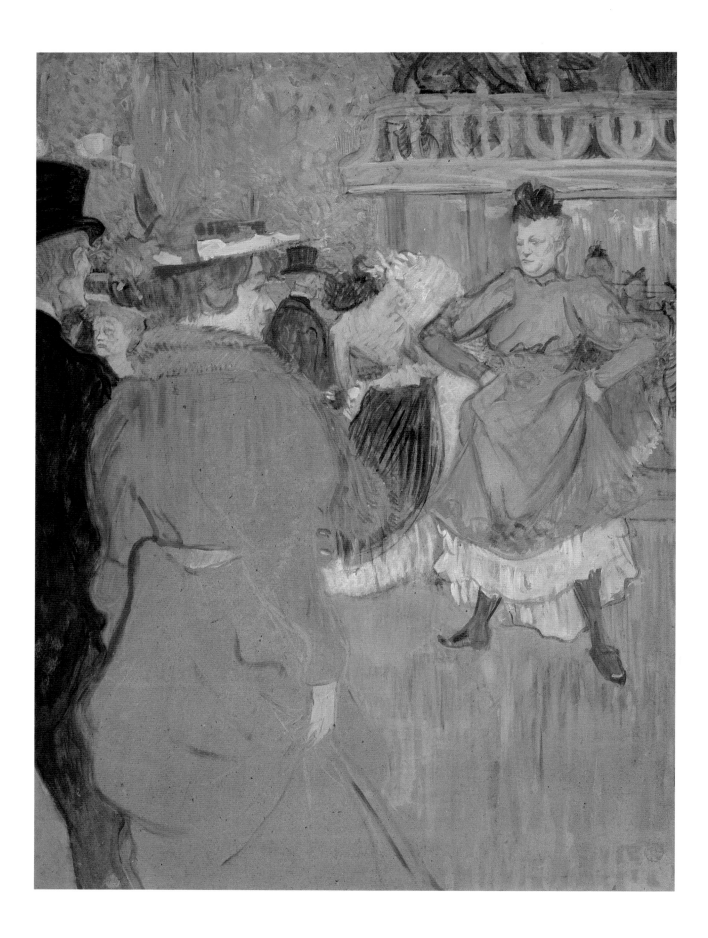

Jane Avril Dancing

1892, oil on cardboard; 33 1/2 x 17 1/2 in. (85.5 x 45 cm). Musée d'Orsay, Paris. The white muslin dress, plumed hat, and swirling black petticoats are the predominant features in this rendering of the famous dancer, who is kicking her left leg sideways in one of the dances that won her so many admirers.

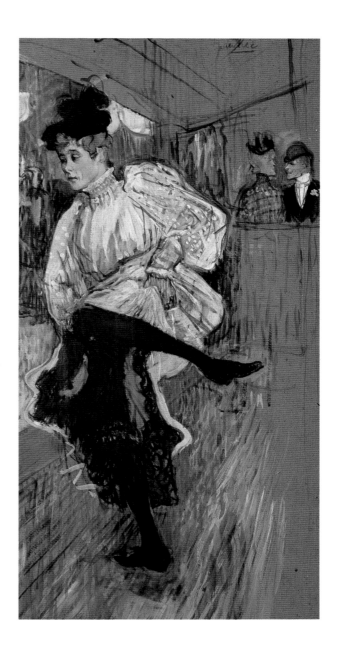

At the Moulin Rouge: The Beginning of the Quadrille

c. 1892, oil on canvas; 31 x 23 1/2 in. (79.5 x 60.2 cm). Chester Dale Collection, The National Gallery of Art, Washington, D.C. The renewed popularity of the *chahut*, a dance of exuberant energy and sexuality, was revived by the star dancer of the Moulin Rouge, La Goulue. The performer invented her own act, the famous "naturalist quadrille," based on the cancan, and performed by two pairs of dance partners.

Yvette Guilbert Taking a Curtain Call

1894, oil on photographic enlargement of a lithograph;
(48 x 25 cm). Musée Toulouse-Lautrec, Albi.

Based on a photographic enlargement of the last lithograph
of the *Album Yvette Guilbert*, the artist shows the singer
taking a curtain call. Lautrec aged the twenty-seven-year-old
performer by emphasizing her thin lips and heavy makeup.

Ballet de Papa Chrysanthème

1892, oil on cardboard; 25 1/4 x 22 3/4 in.
(65 x 58.3 cm). Musée Toulouse-Lautrec, Albi.

In November of 1892, the Nouveau Cirque presented
a new show entitled *Papa Chrysanthème*, the story
of a Japanese prince who returns to his native country
with his European fiancée. Lautrec depicts the cere-
monial dance in which she presents herself at court.

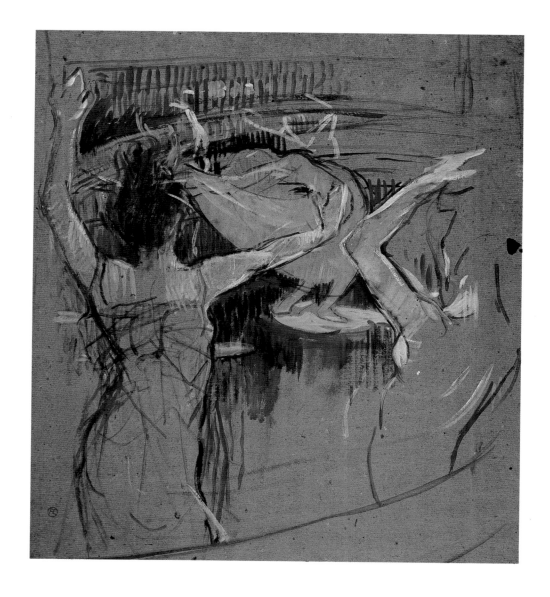

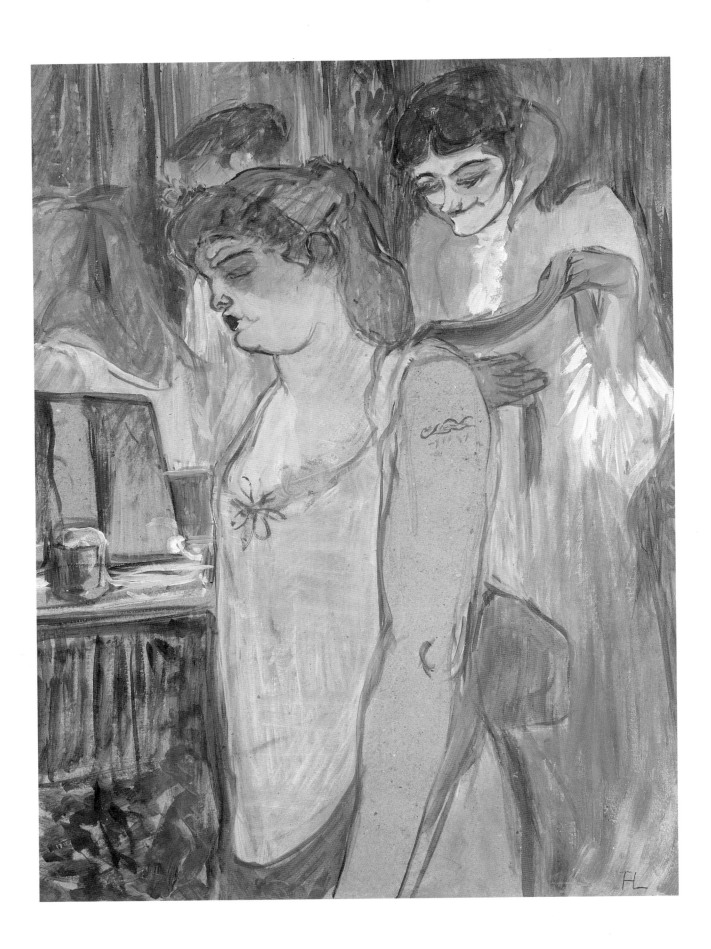

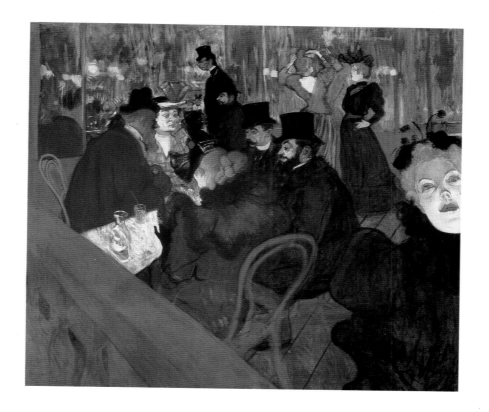

At the Moulin Rouge

1892–1893, oil on canvas; 48 x 55 in. (123 x 141 cm). Helen Birch Bartlett Memorial Collection, 1928.610, The Art Institute of Chicago, Chicago.

Lautrec recreates the Moulin Rouge with eerie effect. A group of the artist's male friends and two women of the establishment are sitting around a table at the center. In the rear, standing before a mirror, La Goulue is adjusting her hair; the sickly, greenish mask at the far right, lit by a stage lamp from below, has been identified both as "Nelly C" and as May Milton.

The Tattooed Woman or The Toilette

c. 1894, oil on cardboard; 24 1/3 x 18 3/4 in. (62.5 x 48 cm). Collection H. Hahnloser, Bern.

Here, Lautrec appears to have used the same models as in *Woman Pulling on Her Stockings*. The younger, heavyset woman, with a tattoo on her upper left arm, stands before a dressing table. The older woman, with a strange smirk on her face, braids her companion's hair.

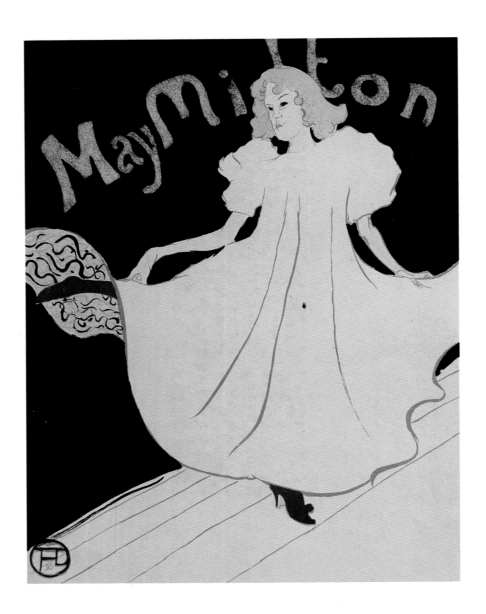

May Milton

1895, chalk lithograph; 31 1/2 x 25 in.
(81 x 64 cm). Free Library, Philadelphia.
May Milton commissioned this poster
for an American tour in 1895. It never
appeared in Paris, but it was published
and shown at the international poster exhibi-
tion in Rheims in 1896. The use of large,
flat-color areas and the decorative emphasis
of the design are Japanese characteristics.

The Opera "Messalina" at Bordeaux

1900–1901, oil on canvas; 39 x 28 1/2 in.
(100 x 73 cm). Mr. and Mrs. George Gard de Sylva
Collection, Los Angeles County Museum of Art.
On December 14, 1900, during his six-month-long
stay in Bordeaux, Lautrec attended the premiere of
the opera *Messalina*. Enthusiastic about the perfor-
mance, he immediately set to work in his studio
painting various scenes based on the libretto, which
had been published in serial form in *La Revue Blanche*.

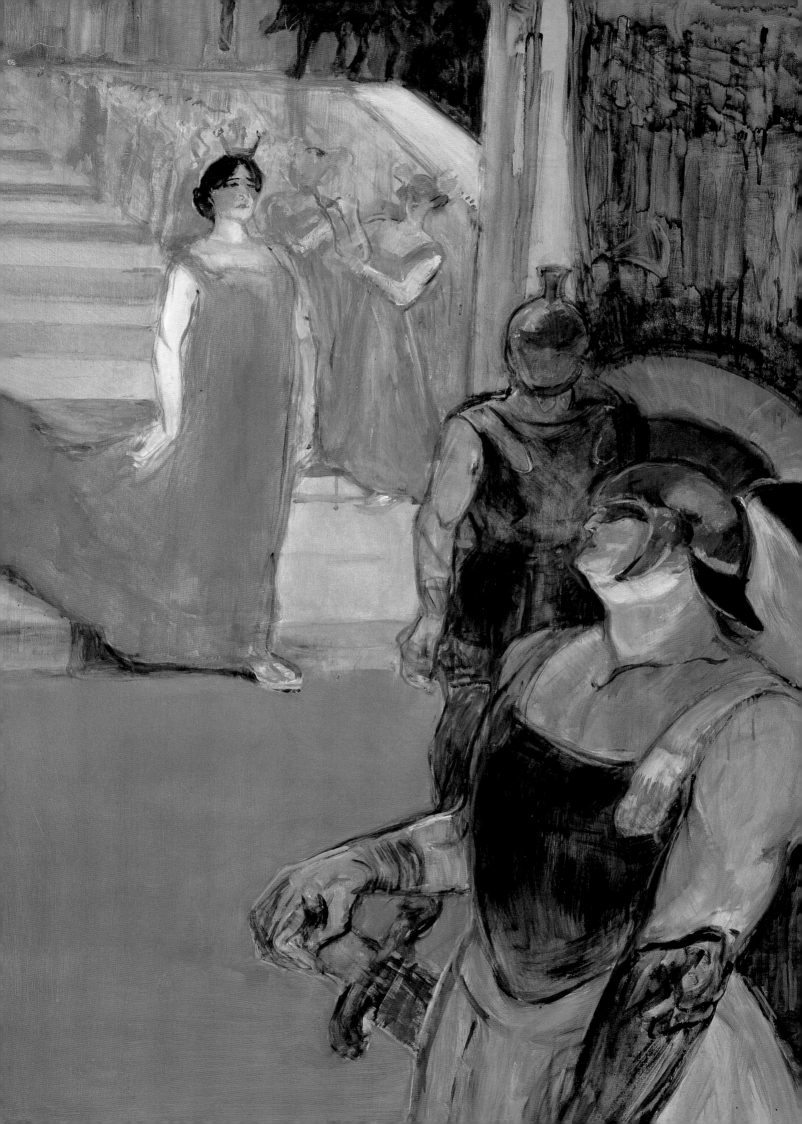

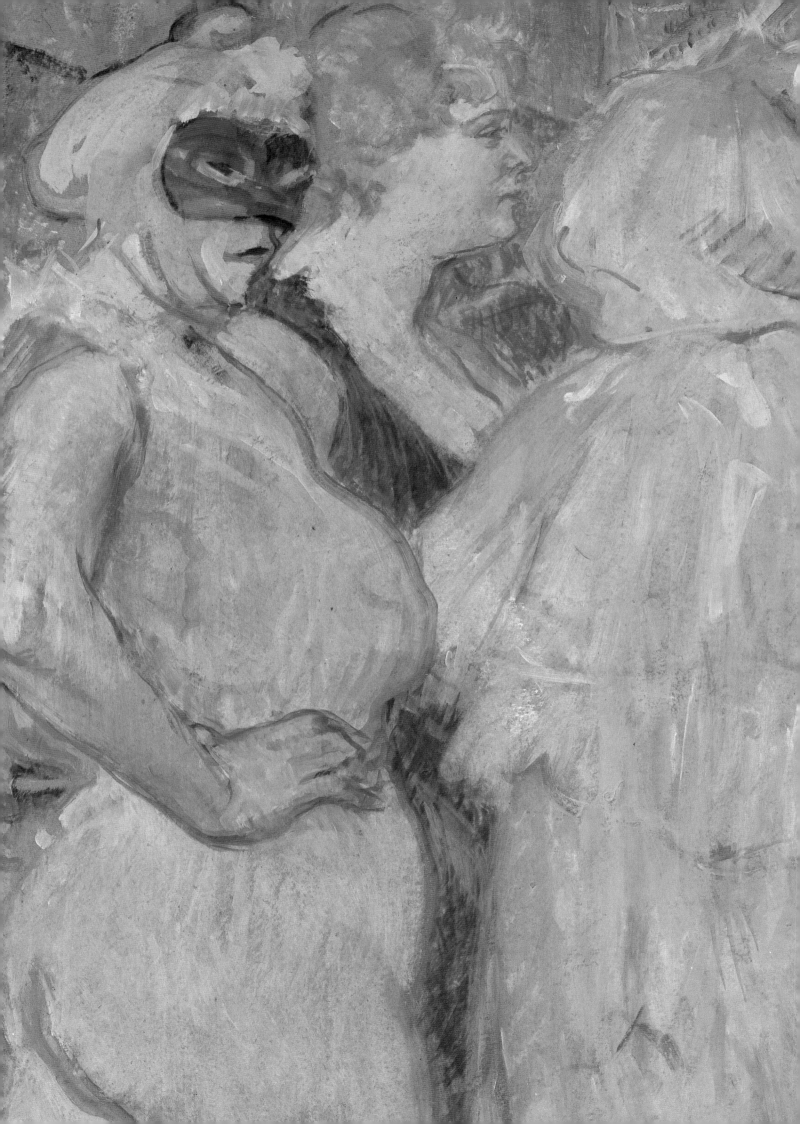

PORTRAITS, ILLUSTRATIONS, AND POSTERS

To his contemporaries, Lautrec was a portrait painter as well as a poster designer. His enormous output of portraits and figure paintings indicates his predilection for the human form. "Only the figure exists," he is quoted as saying by his friend Maurice Joyant. Lautrec's treatment of the human figure is remarkably fluid and varied. He worked from countless angles, painting heads and full length figures in motion or at rest. He placed his subjects indoors and out, and framed them against landscapes and within abstract backgrounds.

Lautrec's portraits are always more than mere likenesses. Indeed, his paintings always include elements that describe the sitters' personality or state of mind. The artist himself summarized his exhibition in London in 1898 with the title, "Portraits and Other Works." In fact, portraits form the majority of his artistic output, though many do not adhere to the classical canon of portraiture painting.

Among Lautrec's portraits one might distinguish between two basic types. The first one shows the individual addressing the viewer in a rather straight-forward manner, sometimes looking into his eyes, other times merely posing self-consciously for posterity. The second group comprises works in which the sitter is shown in a setting that reflects his or her daily life or profession. Some of these paintings resemble traditional portraits, others have transcended the boundaries of portraiture and have a lasting, universal quality.

The Nature of the Individual

For Lautrec, a portrait was a confrontation between the artist and the model. How much should the likeness resemble its model? How many liberties the artist could take to achieve his artistic aim? These questions were a constant part of Lautrec's creative process. Gabriel Tapié de Céleyran claims that Lautrec once invited a man to sit for him by saying: "Monsieur, it would be a great favor to me if you would come to my house and pose for a portrait. It will probably not look like you, but that is of no importance." Tapié once reproached Lautrec for not

Maxime Dethomas: At the Ball of the Opéra

detail; 1896, oil on canvas. Chester Dale Collection, The National Gallery of Art, Washington, D.C.

The woman, wearing a sleeveless jump suit and a black mask, has turned her body in a provocative twist. Pinkish streaks of paint model the voluptuous figure which her costume reveals. In Lautrec's work, women are almost always depicted in a subservient role, or as evocative seducers.

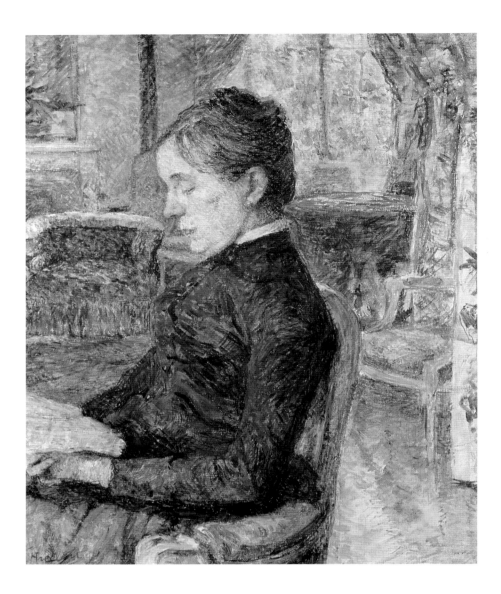

Drawing Room at the Château de Malromé

1886 or early 1887, oil on canvas;
23 x 21 in. (59 x 54 cm).
Musée Toulouse-Lautrec, Albi.
The Countess, a voracious
reader, sits in the drawing room at
Malromé, the house she loved best.
The interior, which she decorated
herself, provides the intimacy of
a protective refuge which Lautrec
would enjoy throughout his life.

finishing his portraits. The artist retorted that there was no need to do so since "the expression is more important than the individual."

Lautrec's artistic aim was to reveal the individual nature of each sitter, blurring the traditional image in order to reach into the mind and soul of his subject. To achieve this, he borrowed from the repertoire of different official styles then in vogue at the Salon, imaginatively transforming the formulas of these styles by using a fresh angle or adopting a different aspect. In this way, he was able to represent the physical and psychological aspects of his sitters. Lautrec, like his fellow Symbolist painters and the Cubists a decade later, synthesized the multiple facets of personality and appearance within the same image. In the artist's early portraits, his subjects posed in front of abstract backgrounds. Later, he began to use the environment to reflect the model's cultural identity.

In the portrait of his mother *Countess Alphonse de Toulouse-Lautrec in the Drawing Room at the Château de Malromé*, the background creates an almost claustrophobic atmosphere. The figure of the Countess is virtually integrated into the interior of the room. The careful choice of decorative details such as ornaments, clothes, and furniture was not accidental, nor was it an aspect of realism—these elements were used to convey his mother's personality as well as a sense of order and beauty. At times Lautrec's demands on his models could border on the extreme. When Louis de Lasalle asked him to paint his portrait, Lautrec accepted "on condition that he cut off his mustaches."

Lautrec was not attracted to landscape painting, however, he occasionally used natural elements as backdrops. The leafy bushes of an abandoned Parisian wasteland were used in the settings of at least two portraits, *Justine Dieuhl* and *Désiré Dihau (Reading a Newspaper in the Garden)*. Unlike the Impressionists, Lautrec was not interested in the study of light and its effects on surfaces, but his palette did become lighter. The subtle arrangements of few colors, mainly green and purple, became one of Lautrec's hallmarks.

Painting outdoors was not an easy matter for the artist. In a letter to his mother dated July 1887, he remarked, "The sky is unsettled." It was the artist's opinion that this showed ". . . how little feeling the Eternal Father has with regard to outdoor painters." Oscar Wilde made the sharp observation that Lautrec's art was "a gallant effort to put Nature back where it belongs."

Following page:

Désiré Dihau
(Reading a Newspaper in the Garden)

detail; 1890, oil on cardboard. Musée Toulouse-Lautrec, Albi.
An abandoned lot on the boulevard Clichy which was used for archery served as backdrop of this painting. Although landscapes interested Lautrec only as a decorative element, he executed them with absolute care. Here, he creates a dense web of interlacing forms with bold brushstrokes.

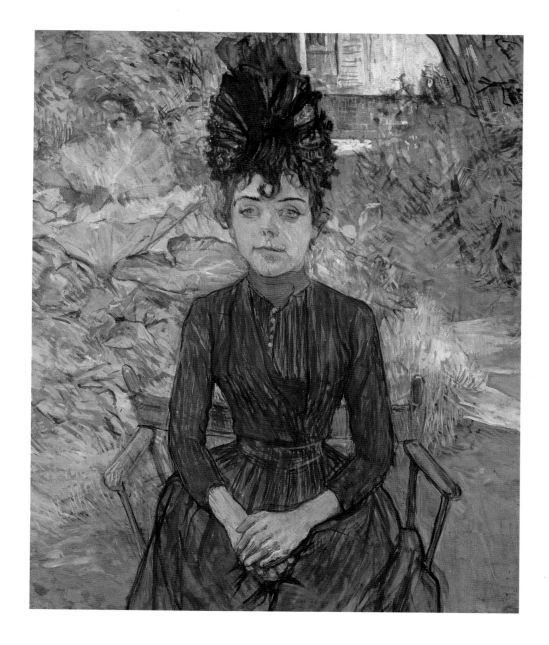

Justine Dieuhl

1889, oil on board; (74 x 58 cm).
Musée d'Orsay, Paris.
Painted outdoors on a bit of wasteland on the Boulevard de Clichy, the sitter is surrounded by the natural setting of leaves and shrubs in full daylight.
The peculiar, elaborate hair style balances the shape of her face. Her somewhat stiff posture contributes to the powerful presence of her figure.

"That Touch of Ugliness"

Lautrec never flattered his models. The asymmetrical beauty of certain women's faces revealed what Edgar Degas called "that touch of ugliness without which there is no salvation." Even in his bluntest depictions, Lautrec never betrays his liking for the subject. Instead, he reduced and concentrated his visual impressions into a set of simplified brush strokes which accurately render the essence of a body or a face. In this sense, Lautrec appears to adhere to what became known as the *Nouvelle Peinture* ("New Painting"). The art critic, Edmond Duranty, decreed the principles of the *Nouvelle Peinture*, when he declared:

> All the particularities of modern man, in everyday dress, against his normal background, at home or in the street . . . The study of a man's morals through his physiognomy of his clothes, the observation of an individual in the intimacy of his own home . . . The portrayal of someone's back view should reveal his character, his age, his social situation.

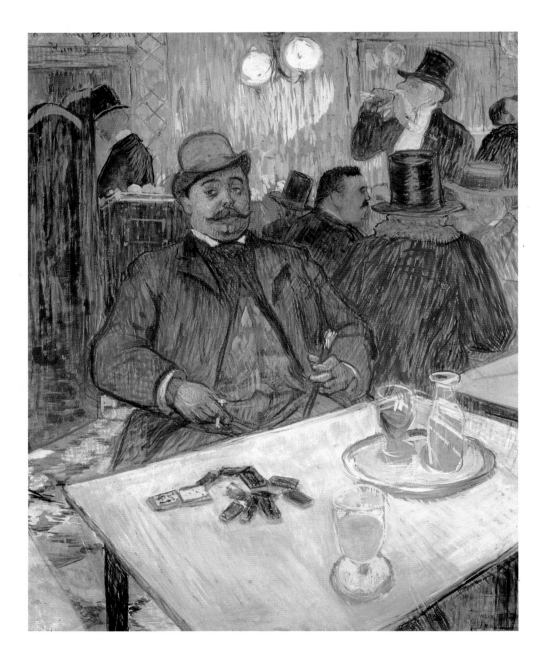

Portrait of Monsieur Boileau

c. 1893, oil on cardboard; 31 x 25 1/3 in. (80 x 65 cm). Hinman B. Hurlbut Collection, 394.1925, The Cleveland Museum of Art, Cleveland, Ohio. Known only by his last name, the sitter is probably one of Lautrec's café acquaintances. He is seated behind a pinkish-gray marble table with a glass of green absinthe, domino pieces, and a tray with a bottle and a glass. Boileau's carefully rendered appearance is that of a well-nourished bourgeois.

Lautrec painted with a directness and subtlety that draws the onlooker into his pictures. A characteristic example is the naturalistic *Portrait of Monsieur Boileau*, who seems to be inviting the spectator for join him for a drink. Some of the women who modeled for the artist were obviously chosen because of their resemblance to certain Parisian stereotypes. Lautrec enjoyed the freedom of financial independence. He was not obliged to paint embellished or rejuvenated likenesses. In fact, he rarely worked on commissions. One notable exception is the *Portrait of Madame de Gortzikoff.*

The sole aim of Salon artists was to show off the beauty of their sitters as well as their social status, focusing especially on the executions of the sitters' head and hands as the expressive window to their soul. Maurice Joyant complained that:

The chronic failure of understanding between painters and their upper-class models grew ever worse; it was caused by mortal fear of being taken for an object of curiosity on one hand, and fear of being ill-used or of not being flattered enough on the other.

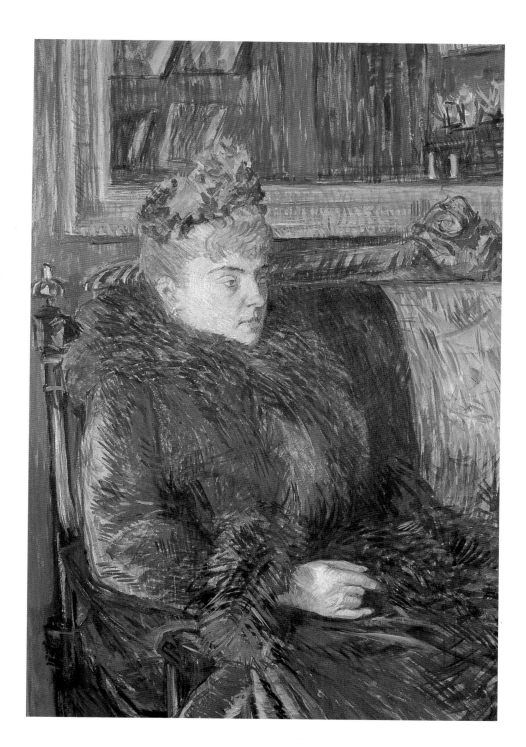

Portrait of Madame de Gortzikoff

1893, oil on cardboard; 29 1/4 x 20 in.
(75 x 51 cm). Private collection, London.

For Lautrec, the pose or stance of his models contributed as much to their characterization as did their features. This portrait is the only commission that Lautrec ever accepted. The busy, cluttered background is clearly intended to show the sitter's state of mind.

Painting Family and Friends

Lautrec changed his choice of models and style throughout his career. At first, under the influence of Princeteau, he painted members of his family and then his friends. In Bonnat's studio, Lautrec refined his technique under the tutelage of the decorated, academic, portraitist. In order to shake off the strictures of formal portraiture, Lautrec needed to know his subject. From the early days, familiarity with the personality of his subjects was always an essential element in his portraiture. This intimacy with his models allowed him to work quickly and spontaneously.

Two or three sittings, and in some cases only one, were sufficient. Nonetheless, Lautrec's portraits have an ultimately, classical quality. The dignity of many of his models, regardless of their class, makes his work a statement about the human condition.

Lautrec's later portraits of his friends often show the sitters in a public space surrounded by dancers, actors, or visitors of a cafe, as is the case with the *Portrait of Monsieur Delaporte at the Jardin de Paris*. Léon Delaporte was a director of a firm which specialized in posters and advertising. Here, he is shown sitting at the Jardin de Paris, the café-concert on the

Portrait of Monsieur Delaporte at the Jardin de Paris

1893, oil on paper on wood; 30 x 27 in. (76 x 70 cm). Ny-Carlsberg Glyptothek, Copenhagen. Léon Delaporte was the director of a firm which specialized in posters and advertising. He is shown sitting at the Jardin de Paris, the café-concert on the Champs-Elysées. Lautrec began the picture in a steep vertical format, and later added a strip on the left side.

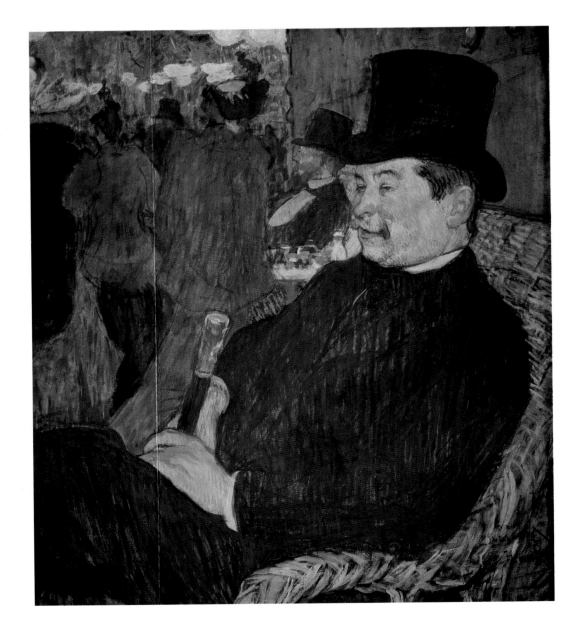

Champs-Elysées. The elegant figures in the background define the setting for this portrait.

Gabriel Tapié de Céleyran in a Theater Corridor is an homage to the cousin who was also one of Lautrec's constant friends. Both men shared a liking for the theater. Lautrec decided to paint his younger relative in the corridors of the Comédie Française. The complex geometric background and the slightly curved brush strokes of the red carpet follow the structure of the theater. An open door of the box on the left offers a glimpse into the interior. This is the world in which Lautrec and Tapié spent their evenings together.

Even in some of his more radical renderings of contemporary life, he included portraiture merging the two genres into one, as can be seen in *At the Table of M. and Mme. Thadée Natanson* or *An Examination at the Faculty of Medicine*. The latter is one of his very last works, it was completed shortly before his death.

The first painting has the characteristics of a sketch, and it includes the portrayals of several guests at a dinner party at the house of Misia Godebska and her husband, Thadée Natanson, editor-in-chief of *La Revue Blanche*, which regularly published the works of the leading avant-garde writers and artists. Lautrec was one of its principal contributors. A fond friendship developed between Lautrec and Godebska, and he chose her figure to adorn the cover of one of the magazine's editions. Her elegant attire—in an ostrich-feathered hat, spotted dress, fur jacket, and muff—expresses perfectly the magazine's style at the *fin de siècle*.

An Examination at the Faculty of Medicine shows Lautrec's cousin Gabriel Tapié de Céleyran being questioned by two professors, Professor Robert Würtz, a friend of Lautrec's, and the white-haired professor Alfred Jean Fournier. Fournier was known for his work on syphilis and alcoholism—the two causes of Lautrec's untimely death at the age of thirty-seven.

In 1899, with the intent to amuse Lautrec after his hospitalization at Neuilly, an attempt was made to direct his talents to the conventional portraiture of cultivated and aristocratic women. It proved in vain. After a few sittings these ladies, initially attracted by

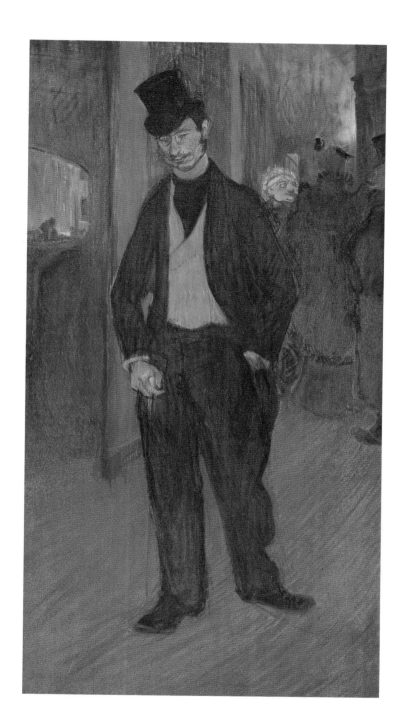

Gabriel Tapié de Céleyran in a Theater Corridor

1893–1894; oil on canvas; 43 x 21 7/8 in.
(110 x 56 cm). Musée Toulouse-Lautrec, Albi.

Gabriel Tapié de Céleyran and Lautrec were first cousins twice over through intermarriage of their families. Five years younger than Lautrec, Tapié came to Paris in 1891 for his medical studies. Both men shared a taste for the theater. Here, Lautrec has painted his relative in the corridors of the Comédie Française.

the artist's reputation, fled from his cruelty. Until the end of his life, Lautrec continued to paint friends, but these portraits could take an increasingly long time. Lautrec needed sixty-five sessions to complete a late portrait of Maurice Joyant.

Lautrec said he attempted to paint "truth rather than the ideal. This may be a mistake, because I don't look with favor upon warts and I like to decorate them with playful hairs." Occasional exaggerations of facial features indicate the fine dividing line between subjective distortion and caricature in Lautrec's oeuvre. The artist was true to Arsène Alexandre's proclamation that "clever the man who can say where caricature begins and where it ends." Lautrec left the realistic rendering of the lines and planes of an individual's face to the portrait photographers of the day.

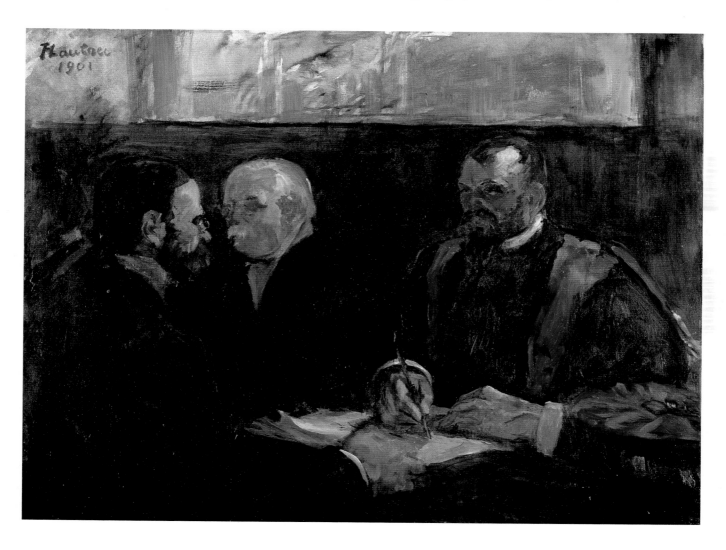

Mademoiselle Dihau at the Piano

detail; 1890, oil on cardboard. Musée Toulouse-Lautrec, Albi.

The painting is characterized by a unified color scheme of predominant blue hues complemented with green dots on the wall and some red on the woman's collar. Marie Dihau and her brother Désiré were not only musicians but also avid art collectors.

An Examination at the Faculty of Medicine

1901, oil on canvas; 25 1/3 x 31 1/2 in.
(65 x 81 cm). Musée Toulouse-Lautrec, Albi.

Gabriel Tapié de Céleyran defends his doctoral thesis before a committee at the medical faculty. The inquisitive professor in an academic robe is Robert Würtz, an old friend of Lautrec's, who was indeed one of Tapié's examiners. The white-haired figure is Alfred Jean Fournier.

Poster Design

Lautrec's contribution to the applied arts, namely that of poster design, intimately linked it with the Art Nouveau movement of the last decade of the nineteenth century. Thadée Natanson published an article in *La Revue Blanche* about the development of this new art style:

. . . the needs and conditions of life today, changing as radically and as fast as they do, make new designs absolutely necessary. This has to be recognized . . . Only then will the ancient prejudices about art for art's sake disappear. The most talented young artists today are more interested in decorating a house or a piece of crockery or cutlery than in casting a statuette or painting at an easel.

This is not entirely true of Lautrec's artistic production. He did a few odd things, such as a stained-glass windows, bookbindings, and some

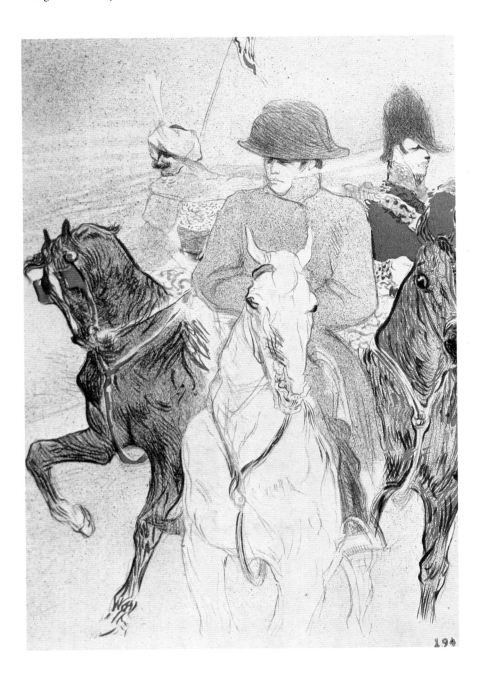

194

Napoleon Bonaparte

1895, lithograph; 23 x 18 in. (59.3 x 46 cm). Free Library, Philadelphia. This unsuccessful entry in a poster competition was Lautrec's only attempt at painting historical subjects. It was created to advertise a serial biography on Napoleon Bonaparte (*L'Histoire de Napoléon I*, written by W. M. Sloane).

La Revue Blanche

1895, chalk lithograph; 50 x 35 1/2 in. (125.5 x 91.2 cm). Musée Toulouse-Lautrec, Albi. In the late nineteenth century, *La Revue Blanche* was a convergence point for Paris's artistic and literary worlds. Illustrations were often provided by avant-garde artists, including Lautrec, who depicted Misia Godebska, wife of the editor-in-chief Thadée Natanson, as the embodiment of artistic fashion.

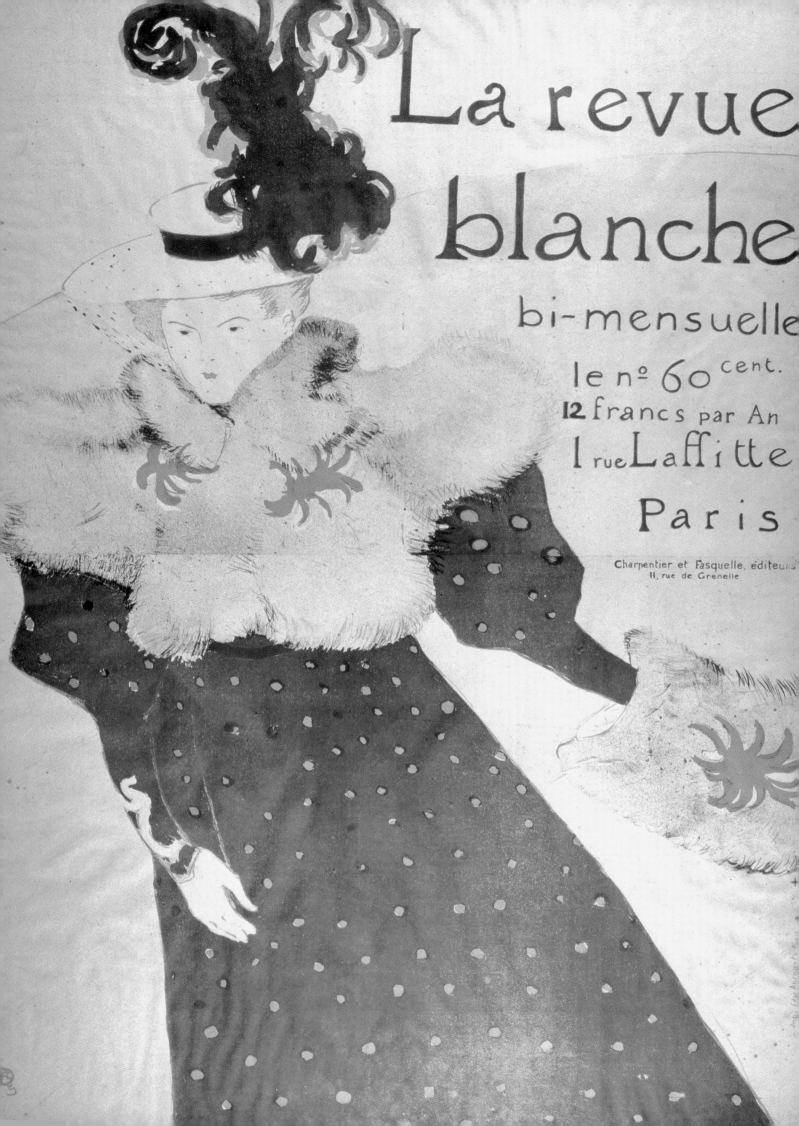

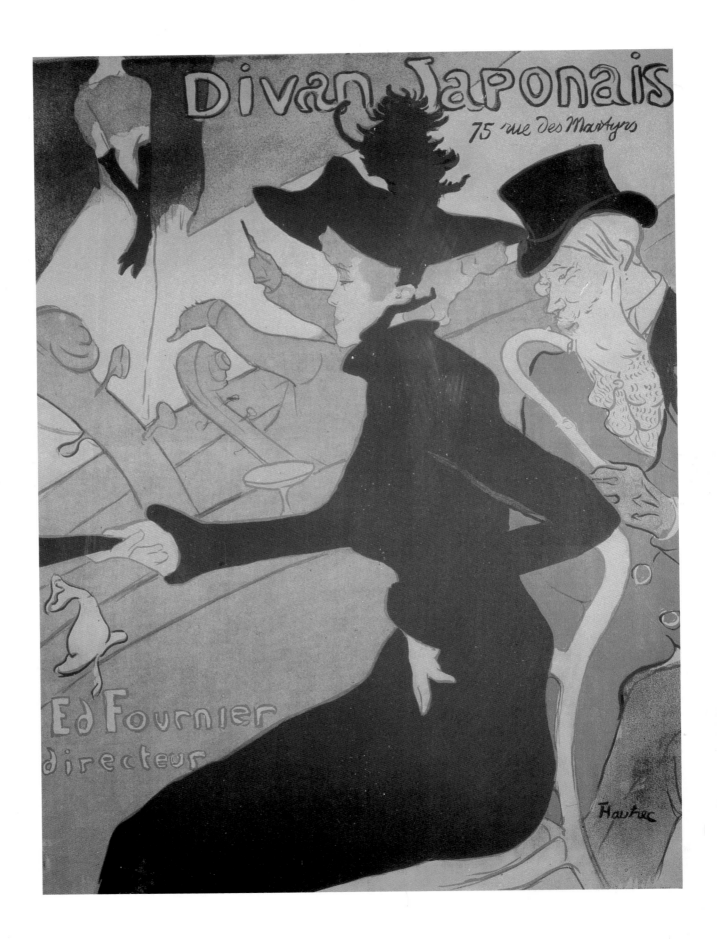

book illustrations (*Napoleon Bonaparte*, for example). His importance lies in his influence on the poster and advertisement design, for Lautrec's activity as a designer coincided with the golden age of the lithograph and the pictorial poster in the 1890s.

Exhibitions of posters promoted this new genre of commercial art. The public became interested in street art, and began treating posters as collector's items. Some posters were deliberately printed in strictly limited editions, and, because of their large size and fragile conditions, were at times reprinted in smaller formats and bound in volumes for easier viewing.

Lautrec created a total about thirty posters, including the well-known designs of *Jane Avril at the Jardin de Paris*, *Le Divan Japonais*, or *Reine de Joie*, which was designed to promote a book of the same title. The importance of his contribution was recognized early on. In an 1893 edition of *La Plume* dedicated to poster design, the art critic Ernest Maindron wrote: "He undoubtedly speaks a new language, but it is a strong, clear and harmonious language which will certainly be understood. All his works are both important and influential."

In the same issue another critic, Franz Jourdain, offered this appraisal:

> Lautrec is supremely in control of his line, handling it with unusual confidence, bending it to the will of the moment: his line is witty, elegant or sad by turns, but always decorative. His tremendous competence as a draftsman allows him to express great character through flat expanses of color . . .

Lautrec borrowed the linear flatness of his images and expressive color fields from Japanese woodblock prints. Known as Ukiyo-e, these prints were very much sought after in Paris. Lautrec's strong, visual images speak a direct, clear language, and his posters are still considered to be among the most eloquent and powerful examples of their kind.

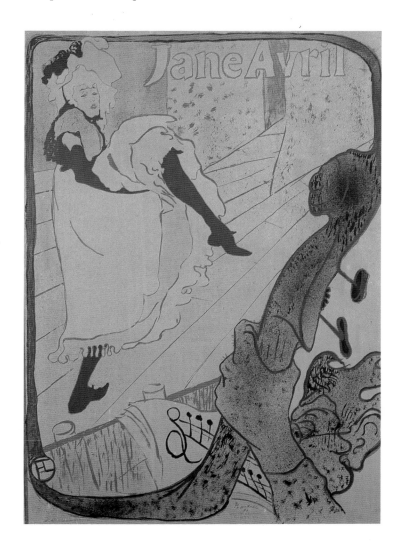

Le Divan Japonais

1893, chalk lithograph; 30 3/4 x 23 1/4 in.
(78.8 x 59.5 cm). Musée Toulouse-Lautrec, Albi.

Lautrec designed this poster for the reopening of a café-concert, Le Divan Japonais, in which he adapted Japanese principles of color and composition compatible with the café's decor. At the center is Jane Avril, behind her the music critic Edouard Dujardin. On the stage beyond the orchestra pit Yvette Guilbert is recognizable by her long black gloves.

Jane Avril at the Jardin de Paris

1893, lithograph; 48 1/4 x 35 1/2 in. (124 x 91.5 cm).
Musée Toulouse-Lautrec, Albi.

This is among the most famous of Lautrec's posters. It was commissioned at Jane Avril's request by the Jardin de Paris, a café-concert just off the Champs-Elysées. The poster's critical success launched the dancer's career. She is seen kicking her leg, a pose Lautrec immortalized.

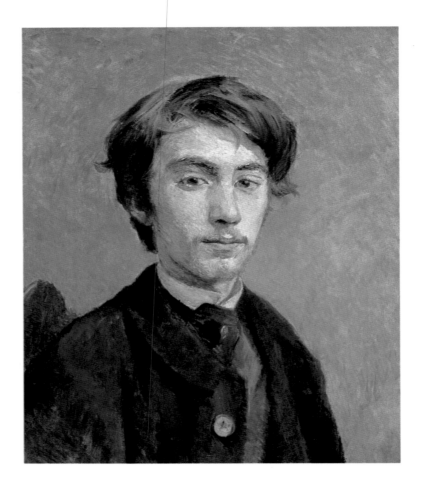

Emile Bernard

1886, oil on canvas; 21 1/4 x 17 in. (54.5 x 43.5 cm). The Tate Gallery, London.
Emile Bernard was one of Lautrec's fellow students in the studio of the
painter Fernand Cormon in Paris. Being of an "argumentative temperament,"
Bernard had to leave the studio after a dispute with his teacher.
Lautrec painted his friend not as a Bohemian artist, but rather as a bourgeois.

First Communion Day

1888, grisaille on cardboard; 24 1/2 x 14 in. (63 x 36 cm). Musée des Augustins, Toulouse. Lautrec's friend, François Gauzi, is the father pushing the baby carriage. Gauzi recollected: "Posing for Lautrec is almost a pleasure. He was not exacting and did not insist on absolute immobility. We chatted away and time flew, enlivened by his off-the-cuff wit, his funny jokes and his good humor."

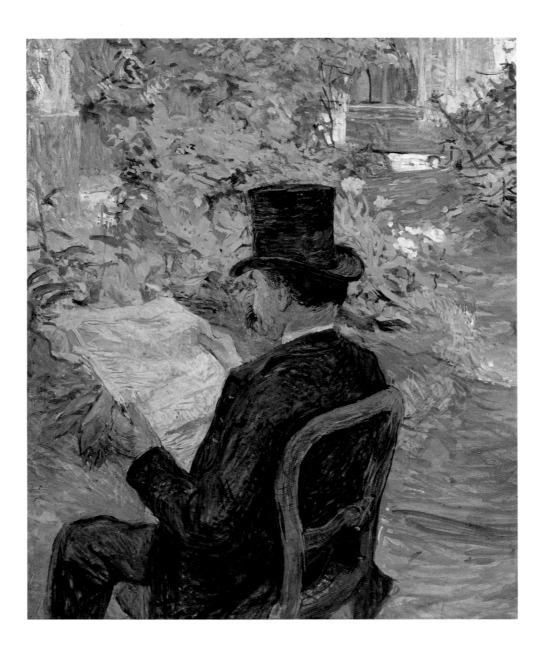

Désiré Dihau (Reading a Newspaper in the Garden)

1890, oil on cardboard; 22 x 17 1/2 in. (56 x 45 cm). Musée Toulouse-Lautrec, Albi.

Désiré Dihau, bassoonist at the orchestra of the Opéra
in Paris and brother of the pianist Marie Dihau, was a
strong supporter of artists and a friend of both Edgard
Degas and Toulouse-Lautrec, to whom he was distantly related.

Mademoiselle Dihau at the Piano

1890, oil on cardboard; 26 1/2 x 19 in. (68 x 48.5 cm). Musée Toulouse-Lautrec, Albi.

The pianist Marie Dihau practices the piano in a corner of her own apartment on the Avenue Frochot. A portrait of her by Degas hangs on the wall to the right. A prominently displayed sheet of music in the foreground pulls the viewer into the intimate performance. Vincent Van Gogh wrote later to his brother Theo referring to this canvas: "Lautrec's painting, a portrait of a woman musician, is amazing; it moved me a great deal."

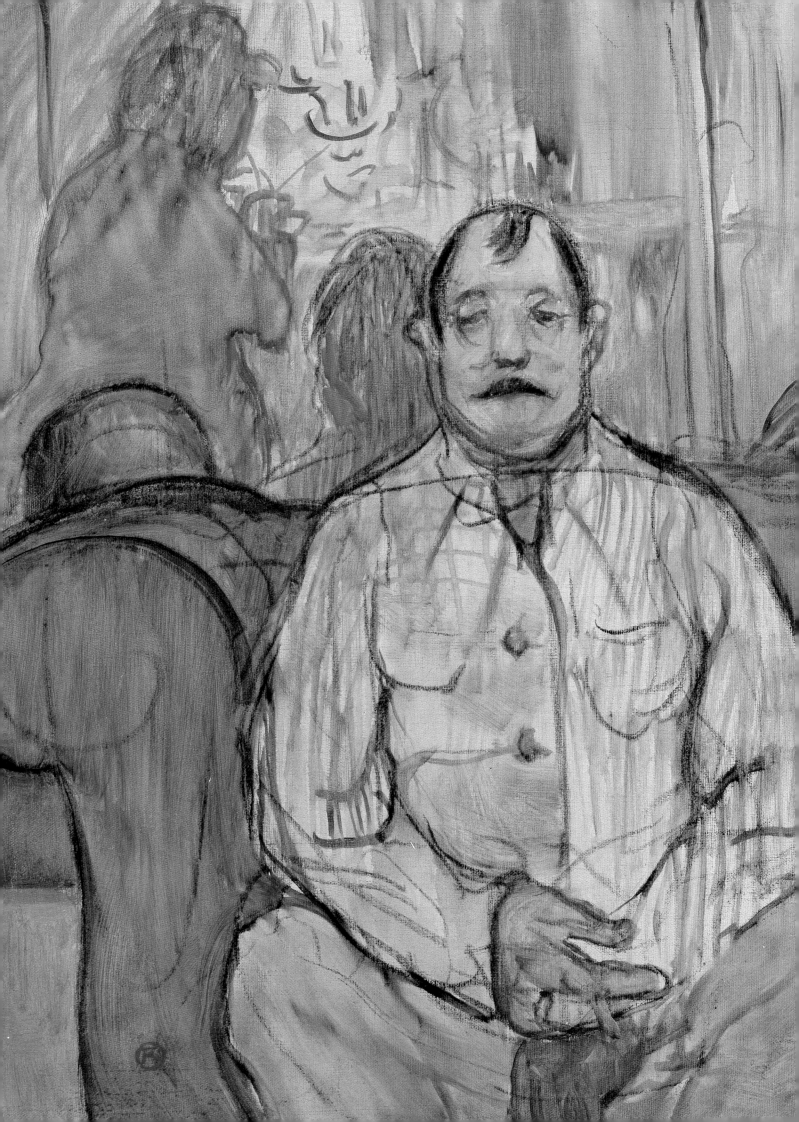

Monsieur, Madame and the Dog

1893, oil and tempera on canvas;
18 3/4 x 23 1/2 in. (48 x 60 cm).
Musée Toulouse-Lautrec, Albi.
According to Maurice Joyant,
this painting shows the owners
of a *maison close*. Lautrec depicts
them as a respectable couple
in control of their business and
conscious of their responsibili-
ties. Seated on a red sofa, a
mirror behind them reflects
their heads. The little lap dog
completes this "family picture."

Study for *Woman Brushing Her Hair*

1896, oil on cardboard; 21 1/2 x 16 1/4 in.
(55.4 x 42 cm). Musée Toulouse-Lautrec, Albi.
For this study for a lithograph in the series
Elles, Lautrec chose a high viewpoint.
Initially drawn in thinned black paint, the
artist worked the sheet up with energetic
strokes of royal blue, black, and white.
The spots visible throughout the sheet
are due to its imperfect state of preservation.

Woman with Black Feather Boa

1892, oil on cardboard; 20 1/4 x 16 in.
(52 x 41 cm). Musée d'Orsay, Paris.
The portrait is painted with Lautrec's
characteristic bravura style of broad, sketchy
brushstrokes, which accentuate the feathery
texture of the dress. The face is rendered with
an insistence on the strangeness of the woman's
features, and the disconcerting gaze of her
slightly sidelong eyes penetrates the viewer.

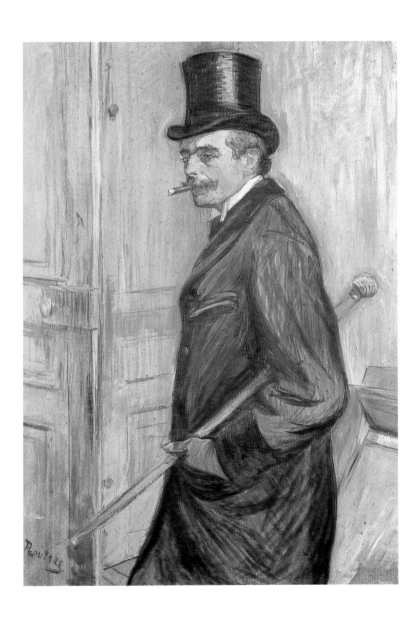

Louis Pascal

1891, oil on board;
31 1/2 x 21 in.
(81 x 54 cm). Musée
Toulouse-Lautrec, Albi.
Dressed in formal
attire, the elegant
figure of Louis Pascal,
a cousin of the artist, is
seen in a three-quarter
profile near a half-open
door. In Lautrec's work,
the handsome man
represents the world
of an idle aristocracy.

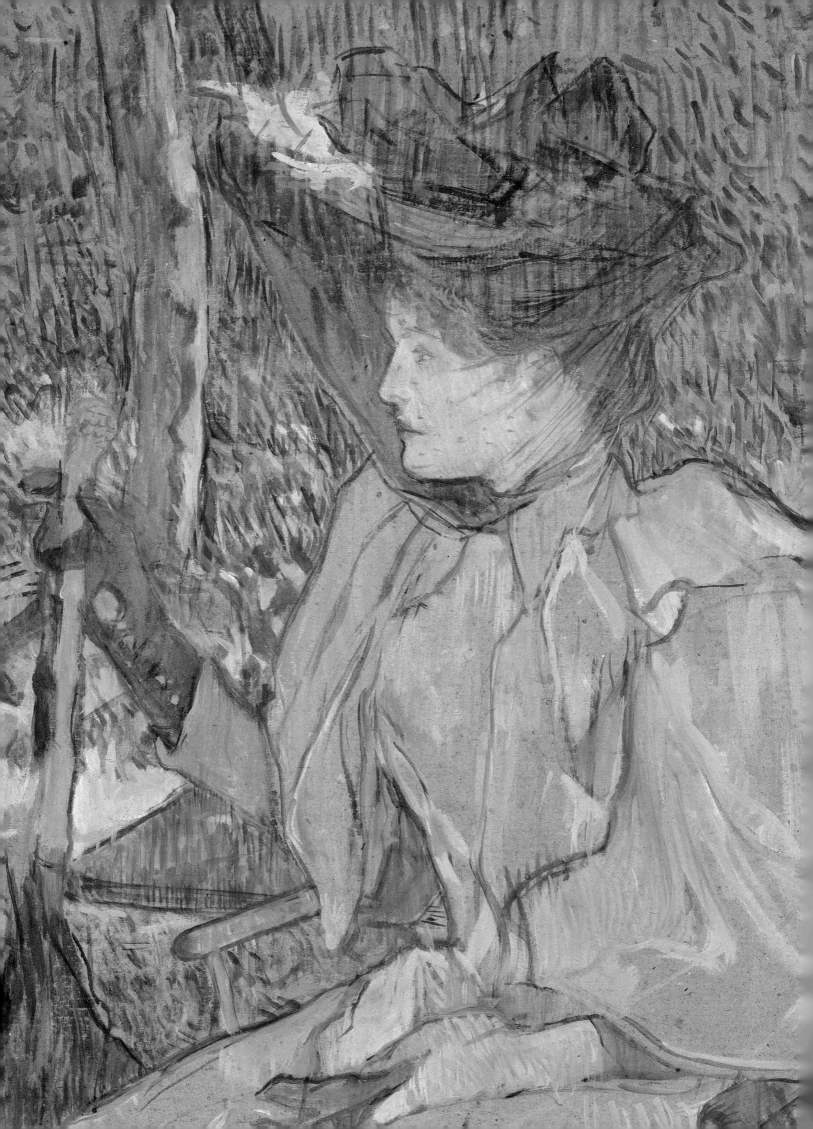

Red Haired Woman Seen from Behind

1891, oil on cardboard;
30 1/2 x 23 1/4 in. (78 x 59.7 cm).
Musée Toulouse-Lautrec, Albi.
This composition was made in preparation for a lithograph of a woman holding a lorgnon. The focus is on her red hair and a small white bonnet. Quickly applied blue lines and amorphous brushstrokes of thinned paint seem to indicate a bow and a scarf framed by a fur collar.

Woman with Gloves (Honorine Platzer)

1891, oil on cardboard; 21 x 15 1/2 in. (54 x 40 cm). Musée d'Orsay, Paris.
It has been suggested that the sitter, a woman of a respectable bourgeois family, was willing to marry the artist. She is seated in a garden chair, and her face is shown in profile. Green and brown hues dominate the coloristic effect.

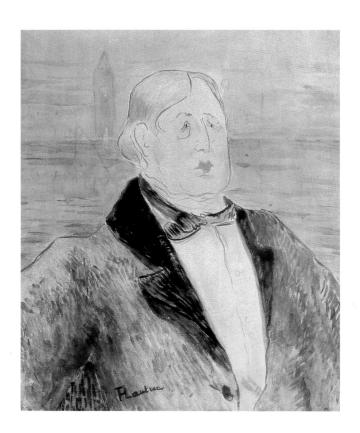

Oscar Wilde

1895, watercolor, 22 7/8 x 18 3/4 in. (58.5 x 48 cm). Private collection. This watercolor seems to have been done from memory. It is not clear if Lautrec ever met the writer, although he was present at Oscar Wilde's trial in 1895. Prosecuted and imprisoned for his homosexuality, Wilde fell prey to Victorian puritanism, becoming the archetype of the artist as martyr.

La Belle et la Bête

1895, oil on cardboard; 13 1/4 x 9 3/4 in. (34 x 25 cm). Fundaciòn Colecciòn Thyssen-Bornemisza, Madrid. René Weil, who published under the pen-name Romain Coolus, was a member of the *Revue Blanche* and author of *La Belle et la Bête*, for which Lautrec painted some illustrations including this work. The caricature-like figures of a man and a woman seem to have been observed in the streets of Paris, and are imbued with a characteristic sense of humor and a warm feeling for the human condition.

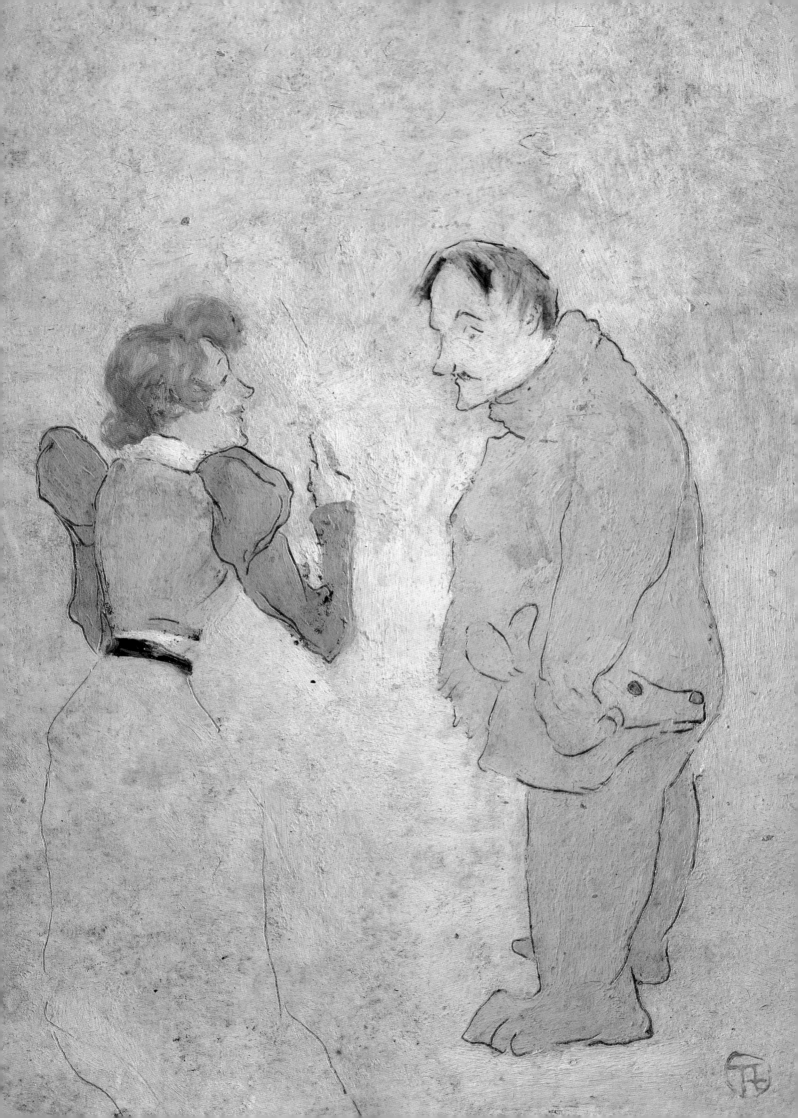

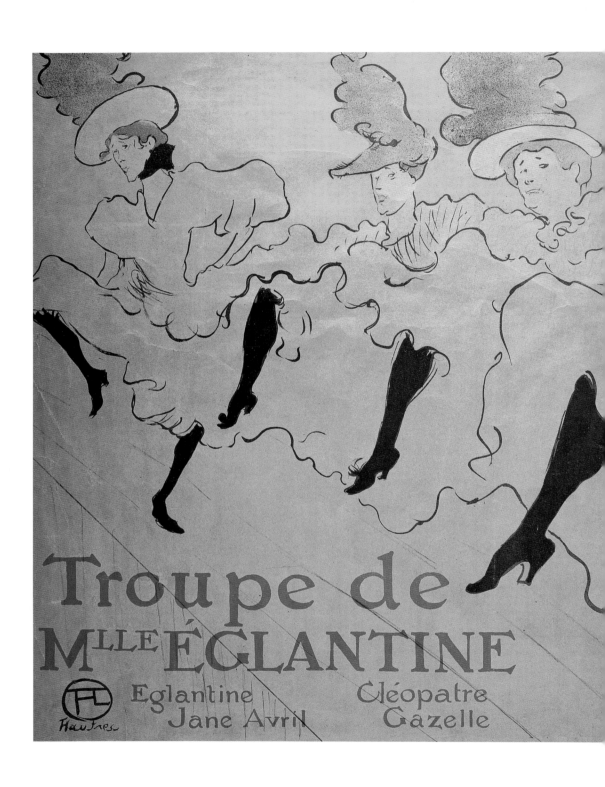

Troupe de Mademoiselle Eglantine

1896, chalk lithograph;
24 x 31 1/4 in. (61.7 x 80.4 cm).
Musée des Arts Décoratifs, Paris.
In 1896, the troupe of Eglantine
Demay appeared at the Palace
Theater in London. Lautrec designed
the poster showing the group's four
members, from left to right: Eglantine
Demay, Jane Avril, Cléopâtre, and
Gazelle. Using a photograph as starting
point Lautrec painted the dancers' flounced
petticoats like a large cloud placed diago-
nally across the wooden dance floor.

Invitation to a Cup of Milk

1897, chalk lithograph; 15 x 9 3/4 in.
(38 x 25 cm). Musée Toulouse-Lautrec, Albi.

This invitation to a house-warming in Lautrec's
new apartment at 5, avenue Frochot, near the
place Pigalle, reads: "'Henri de Toulouse-Lautrec
will be most flattered if you will pay him the
compliment of accepting a cup of milk on Satur-
day 15 May at approximately half-past three." The
artist depicted himself as a cowherd with a whip
facing a magpie beneath the cow. As the French
words for magpie (pie) and the cow's udder (pis)
are phonetically identical, the ironic juxtaposition
of the two animals thus reads: "pie" + "pis" = pipi.

Loïe Fuller

1893, lithograph; 14 1/4 x 10 1/2 in.
(36.8 x 26.8 cm). Bibliothèque Nationale,
Collection des Estampes, Paris.

This lithograph was printed in an edition
of about sixty copies. Each print features a
different combination of colors, controlled
by the artist. Thadée Nathanson evoked the
expressive quality of this print: "Loïe Fuller
closely combines the flame and the dance. With
their metallic glitter, Lautrec's lithographs cap-
ture the reality, or the apparition, of the living
flame, mimicked by flying veils and by the blaze
and shifting colors of the revolving spotlights."

May Belfort

1895, lithograph; 23 1/2 x 31 1/2 in. (80 x 60 cm). Musée Toulouse-Lautrec, Albi.
May Belfort was an Irish singer who was performing at the café-concert
"Les Décadents," where Lautrec discovered her. He was immediately
taken by the singer's personality and painted this poster for her.

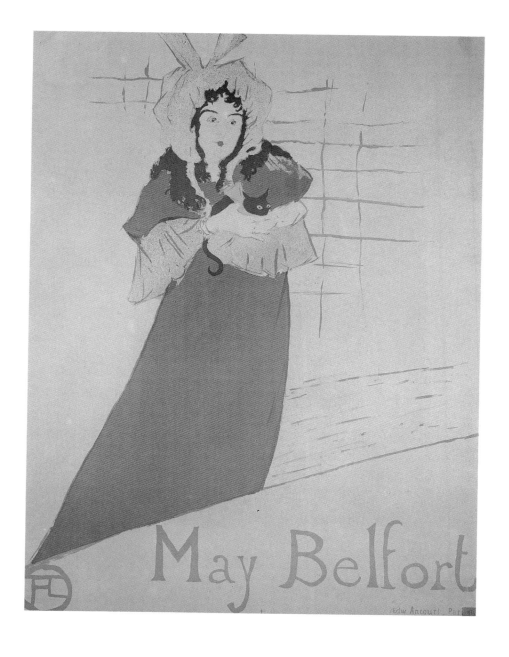

Maxime Dethomas: At the Ball of the Opéra

1896, oil on canvas; 26 1/2 x 20 1/2 in. (67.5 x 52.5 cm).

Chester Dale Collection, The National Gallery of Art, Washington, D.C.

Lautrec's later portraits of his friends often show the sitters in a public space

surrounded by dancers, actors, or visitors in a café. Here, the painter Maxime

Dethomas is seen seated at a table during a masked ball at the Paris Opéra.

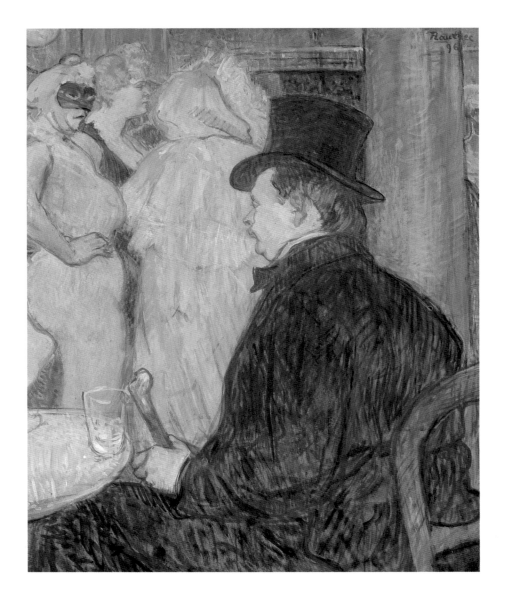

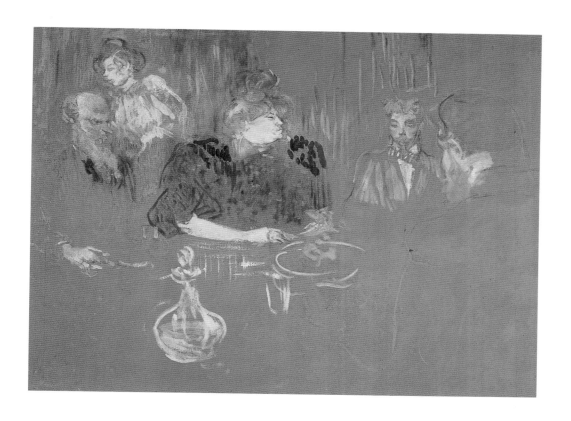

At the Table of
M. and Mme. Thadée Natanson

1895, oil, gouache, and pastel on cardboard; 23 1/2 x 31 1/2 in.
(60 x 80 cm). The John A. and Audrey Jones Beck Collection,
on extended loan to the Museum of Fine Arts, Houston.

As the editor-in-chief of *La Revue Blanche*, Thadée Natanson
(1868–1951) often invited artists and writers to dinners at his
home in Paris. The present sketch shows, from left to right,
Edouard Vuillard, who painted at least two portraits of Lautrec,
a massive woman, perhaps an unflattering depiction of Misia
Natanson, the editor's young wife, the Swiss painter Félix
Vallotton, and the bulky figure of the host, Thadée Natanson.

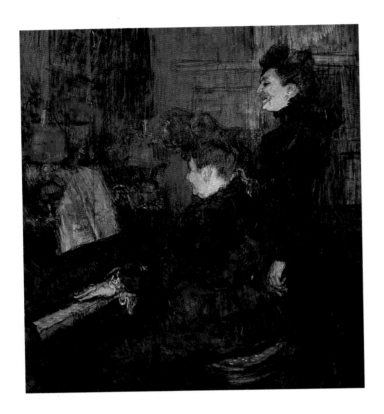

**The Singing Lesson
(The Teacher,
Mlle. Dihau, with
Mme. Faveraud)**
*1898, oil on cardboard,
mounted on wood; 29 1/2 x 27 in.
(75.7 x 69 cm). Mahmoud
Khalil Museum, Cairo.*
In this second portrait of
Marie Dihau, the pianist is
accompanying her student
Jeanne Faveraud. The angle is
slightly different in this portrait,
and the distance greater. Dihau's
figure has become rounder
during the eight years between
the two paintings and the back-
ground is rendered generically.

Amazone
1899, oil and gouache on board; 21 3/4 x 16 1/2 in. (55.5 x 42.5 cm). The Tate Gallery, London.
In common French language the word Amazon refers to a proud woman as well as
to the mythological Greek women known for their strength and independence.
The body of this elegant if enigmatic figure forms a harmonious unity with the horse.

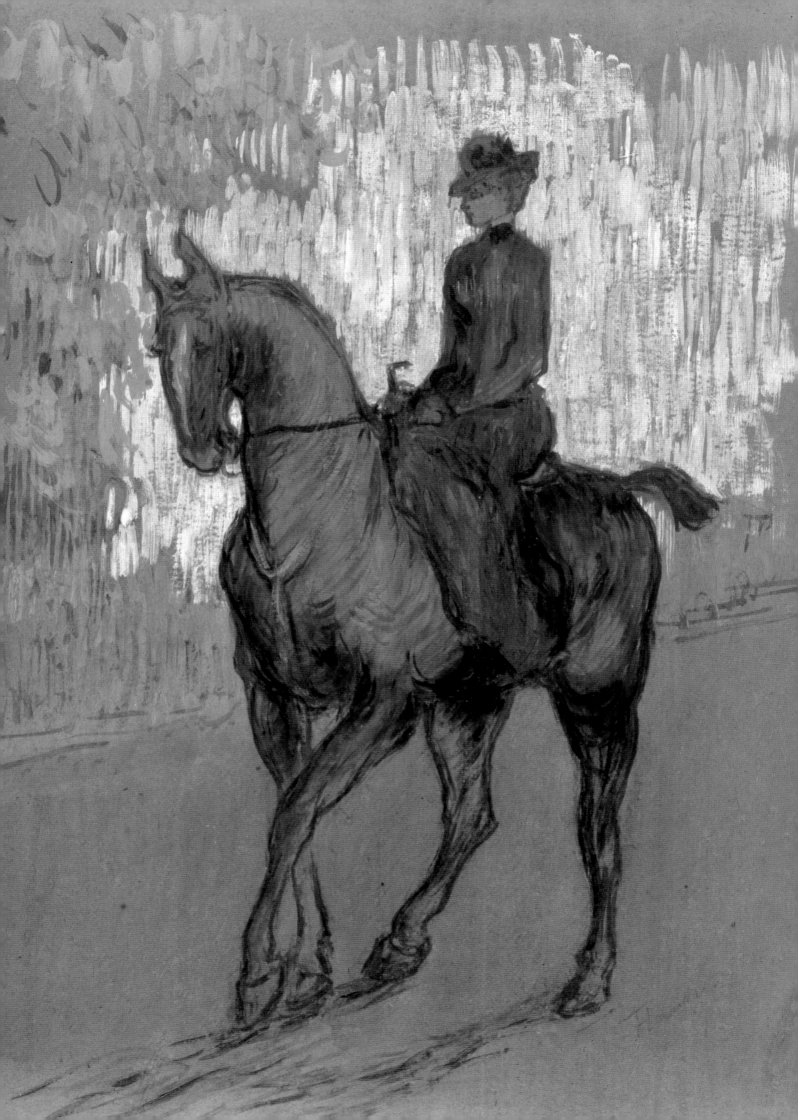

INSIDE THE "MAISONS CLOSES"

Lautrec is perhaps best known today for his depictions of brothels and the prostitutes who inhabited them. During his lifetime, these works were among his most controversial, yet there is little in them that would shock an observer today—unless it is their utter truthfulness. Lautrec's supporters and friends appreciated that these studies—so much of the time—were for all time. His adversaries relentlessly criticized the work, insisting that the paintings of the *maisons closes* ("closed houses") revealed the artist's own depravity.

Yvette Guilbert and Edouard Vuillard both believed that Lautrec found an ease and acceptance in the closed female community of the brothels, and the prostitutes provided him with a sympathetic surrogate family. Maurice Joyant defended his friend's choice of subject-matter, likening Lautrec to Giotto, and Lautrec's images to the sparse, moving, religious works of the early Italian Renaissance.

Impact of the Industrial Revolution

The mid-nineteenth century was the heyday of luxurious Parisian brothels, and the lives of the prostitutes in these houses were treated successfully in the literature of the day. Most notable among these publications were the novels

In the Salon at the Rue des Moulins

detail; c. 1894, charcoal and oil on canvas. Musée Toulouse-Lautrec, Albi.

The staring gaze of the two women neither invites nor rejects us. We see them from the same level as if we, too, were seated. The third woman, seen in profile, can be identified as Rolande, who also appears in other paintings.

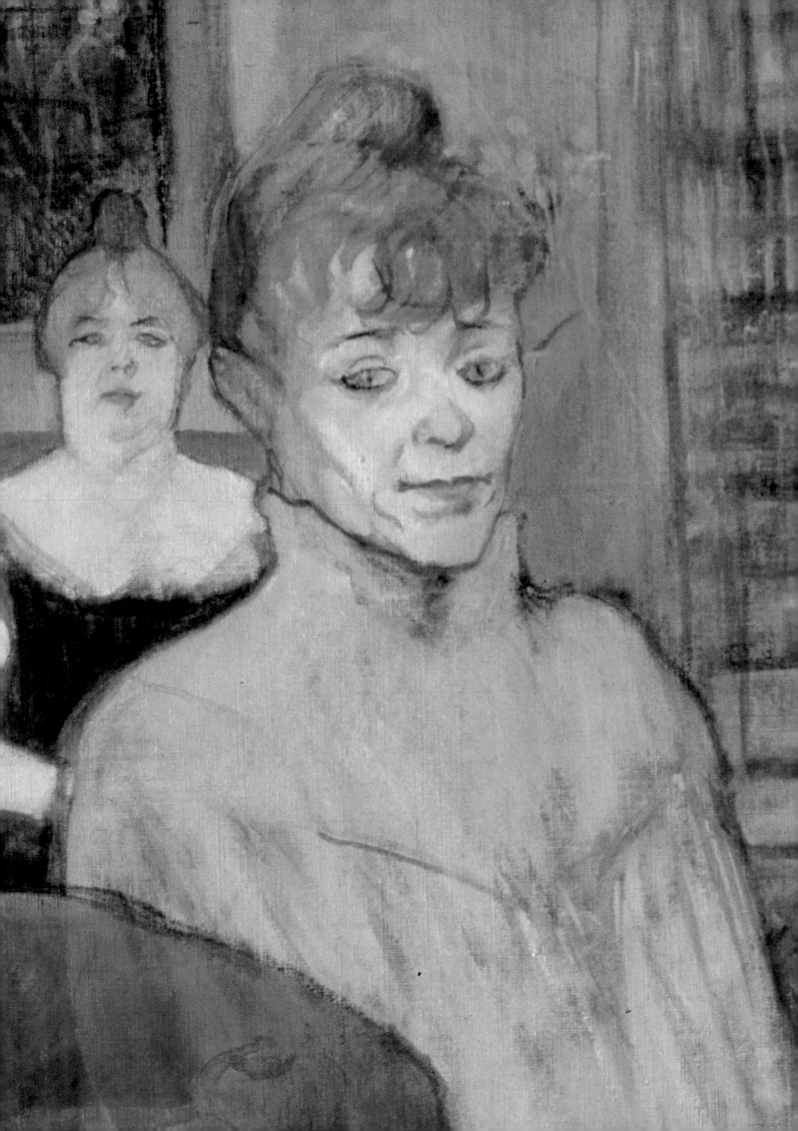

La Fille Elisa (*The Girl Elisa*) by Edmond de Goncourt, *Marthe* by Joris-Karl Huysmans, and *La Maison Tellier* (*The Tellier Brothel*) by Guy de Maupassant. To a large extent, the rise in prostitution was caused by the Industrial Revolution. The profits supported the growth of a middle-class that now had more leisure time in which to indulge in bodily pleasures, but the benefits of industry did not improve the miserable economic situation of those dwelling in the rural areas of France. Hundreds of thousands of young men and women uprooted themselves from the provinces and travelled to Paris to seek work. The hopes of many women to land a decent job and perhaps marry in the French capital faded quickly; those who did not work in factories became servants, maids, and laundresses for the bourgeoisie.

For many of these single, young women, the strain of work and city life proved very lonely and difficult. Thousands suffered from hysteria and other related syndromes. They received treatment in the advanced clinic of the Salpetrière hospital under its famous psychiatrist Dr. Charcot (1825–1893). The appeal of the *maisons closes* to these young women who needed refuge and employment was that of a safe haven, and a sociable environment with sympathetic friends. The inclusion in a close community often surpassed any moral doubts, and these establishments gradually replaced the lost or dysfunctional family bonds.

Many women had no other choice but to become prostitutes. They populated an ever increasing number of brothels and establishments within the entertainment business of Paris, furnishing the comfortably well-off gentlemen of Paris with cheap amusement and licentious adventure. The *maison closes* provided these same gentlemen, who sought privacy and intimacy, with an environment that was not unlike a comfortable gentleman's club.

Brothels were often lavishly furnished and decorated. One of them, *Le Chabanais*, was internationally known for its Oriental and Japanese suites, and it counted among its regular guests many members of the highly fashionable Jockey Club. (The Japanese room in another *maison close* on the rue des Moulins won a prize for its decoration at the Universal Exposition of 1900.) In 1892, Lautrec received a commission to decorate a brothel on the rue d'Amboise with sixteen large canvases to be displayed on the walls of the main reception room. Only two of these canvases were actually painted by Lautrec himself. The others were done with the help of a housepainter and an art student. Unfortunately, this set was broken up, and sold in separate pieces shortly after the First World War.

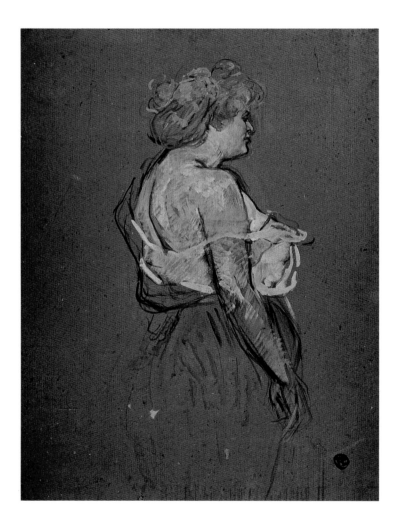

Lucie Bellanger

c. 1895-1896, oil on cardboard; 31 1/2 x 23 1/2 in.

(80.7 x 60 cm). Musée Toulouse-Lautrec, Albi.

Lucie Bellanger was one of many *filles de maison* ("prostitutes") depicted by Lautrec. The woman's powerful torso is imbued with grace by the attitude of her head and the fluid lines of her breast and chemise strap.

Class and Gender

Sexuality became divided by class and gender. The libido of a bourgeois male found its release outside his own well-protected family among lower- and working class women. This search for pleasure was coined with the hideous expression as *égout des spermes* (literally "sperm sewer"). The brothels actually helped maintain the sacred social structure of the bourgeois family. Wives would simply continue to fulfill their duties of childbearing and rearing. If the urgency of a husband's sexuality was too pressing, it could be satisfied elsewhere. Families hoped to be protected from scandals associated with extramarital affairs among their own peers; they also hoped, just as well, that they would be protected from disease.

Prostitution was operated legally and controlled by the *police des moeurs* ("police surveillance of brothels"). *Soumises*, registered prostitutes, were allowed to work under the immediate supervision of a *madame*. Regular medical inspections were designed and implemented to prevent the spread of venereal disease. When, in the 1870s and 1880s, economic forces propelled the proliferation of prostitution, the offices charged with the regulation of the brothels, could not control the increase. Pressed by financial need, illegal prostitutes, the *insoumises*, multiplied on the streets of Paris. (Contemporary estimates vary on the numbers of women who took to prostitution to support themselves, they range between thirty thousand and 120,000 in Paris alone.) Policing was made more difficult by the advent of cheap, department store clothing which blurred the distinction

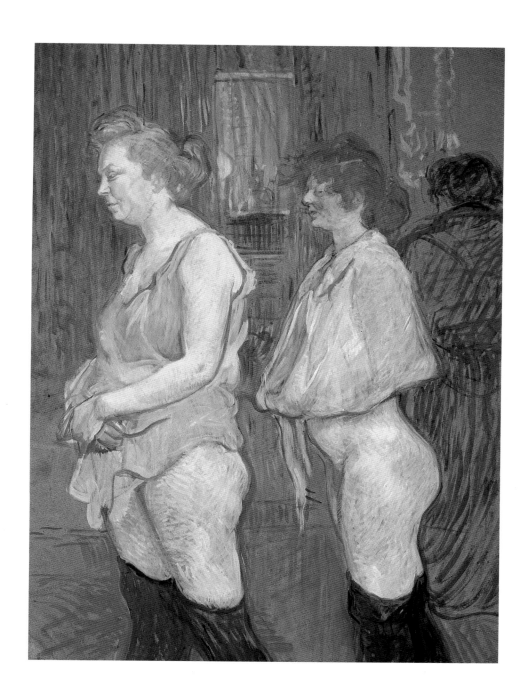

Rue des Moulins

1894, oil on cardboard; 32 7/8 x 24 1/8
(83.5 x 61.4 cm). Chester Dale Collection,
The National Gallery of Art, Washington, D.C.
Two prostitutes of a brothel on the rue des
Moulins wait patiently for their medical inspection,
a procedure designed and implemented to prevent
the spread of venereal disease. Lautrec depicted
these two women in a passive attitude, lining up
just before undergoing the humiliating procedure.

between the classes, making it more difficult to tell who was respectable and who was not.

When Lautrec began to paint the *maisons closes* the brothels of Paris were already in decline. In 1856, Paris counted 202 brothels, this number decreased to only 80 in 1886, and 65 in 1888, with mere 686 *filles de maison*. More and more, prostitution flourished on the boulevards and in bars with private back rooms, where more money could be earned quickly. The *maison close* did not suit the increasingly fluid character of Parisian prostitution. Gradually, public perception of this profession took on a less condemnatory and a more humane tone. In 1890, the city councilor Richard acknowledged that prostitutes were actually "*plus malheureuses que coupables*" ("more unhappy than guilty").

Discourse about prostitution had its place in the public debate at least since mid-century. The outcry over Edouard Manet's *Olympia*, shown at the Salon of 1865, is a case in point. Ambiguous depictions of women who could be either bourgeoises, *filles*, or of a less respectable but indeterminate status dominated the public debate. It seems that Lautrec deliberately cultivated such ambiguities, and he courted the equivocal readings of his contemporaries which were used to decode their society.

Lautrec's Oeuvre

Lautrec's oeuvre can not be dissociated from this sociological phenomena. One might even wonder if he would have had the same success with his work if he had chosen another subject matter. He did not. To his mind, prostitutes made perfect models. He once said, "The professional model is always like a stuffed owl . . . These girls are alive."

It is difficult to place all of Lautrec's paintings of the *maisons closes* in chronological order. Many of the smaller studies were probably made inside the *maisons closes*, larger, more complex compositions were posed, perhaps by prostitutes, in the studio or developed there from preliminary sketches.

He was not the first artist to derive inspiration from the women of Paris' brothels. Forain, Daumier, and Degas also painted the *soumises*, but none became as intimately familiar with them as did Lautrec. At times he would "disappear," leaving his studio on the rue Toulaque for the brothels of the rue Joubert, the rue d'Amboise, or the rue des Moulins, in the *quartier* around the Opéra and the Bibliothèque Nationale. Though male residence in a brothel was against the law, Lautrec would spend days, at times even months with the maison's residents, painting and drawing incessantly. An anecdote tells us that, when the art dealer Paul Durand-Ruel (who had helped promote

Prostitutes around a Dinner Table

c. 1893–1894, oil on canvas; 23 1/2 x 31 3/4 in. (60.3 x 81.5 cm).

Museum of Fine Arts (Szépmüvészeti Mùseum), Budapest.

The heads of these prostitutes gathered around a dinner table at a *maison close* are probably based on portrait drawings which Lautrec made during his visits. The large empty table in the foreground creates a distance between the spectator and these women caught at a quiet moment.

The Laundryman at the Brothel (Le Blanchisseur de la "Maison)

detail; c. 1894, oil on cardboard. Musée Toulouse-Lautrec, Albi.

Here, Lautrec delivers a precise rendering of human expression, transforming the washerman's face into that of a representative type of workman from the lower classes. The man's haggard features are modeled with bold brushwork.

**Study for *Elles*:
Woman in a Corset**

*c. 1896, black and blue
chalk and oil on paper,
laid down on canvas;
40 1/2 x 25 3/4 in.
(104 x 66 cm). Musée
des Augustins, Toulouse.*
A large oil study for a
lithograph of *Elles*, the
scene is unique in this
series of women as it
includes the figure of a
man, who appears to gloat
over the woman. According
to Lautrec's biographer
Maurice Joyant, the model
for the man was the Australian
painter Charles Conder.

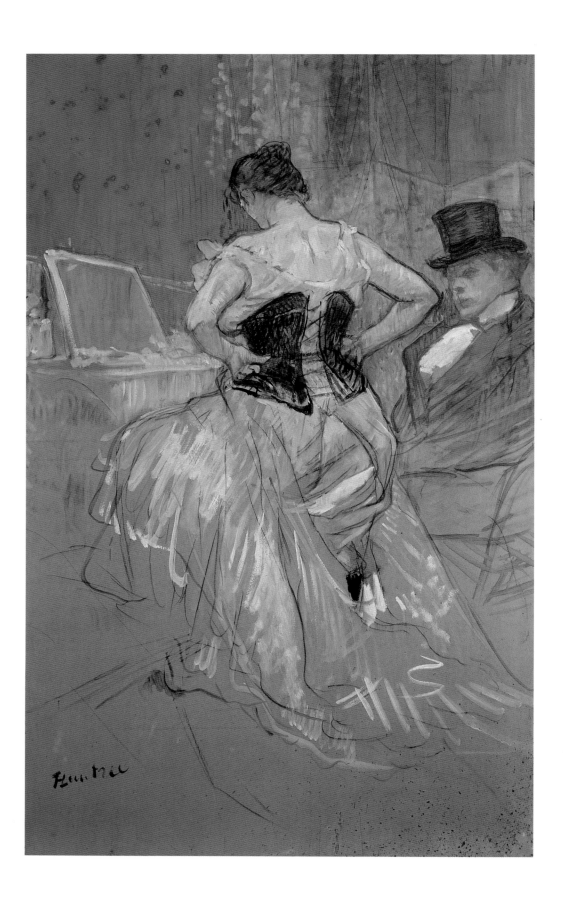

the Impressionist cause) asked to see the artist, Lautrec received him nonchalantly in a brothel of the rue des Moulins. "I hear the word brothel on all sides," Lautrec wrote mockingly, "but have never felt more at home."

Many of Lautrec's paintings of the *maisons closes* are actually domestic scenes of women making beds, getting dressed, combing their hair, relaxing after work (*Study for Elles: Woman on her Back—Lassitude*), or chatting around the dining table during off hours as in *Prostitutes around a Dinner Table*. Sensational in its accuracy are the renderings of prostitutes lining up for the medical inspection (*Study for "The Medical Inspection"*). Prurience rarely enters into the work, the rare exception may be *The Laundryman at the Brothel*. In this painting, the lusty, greedy eyes of the washerman stare out of a haggard, sallow face. Such motifs are exceptional, and may have been intended as private amusements for the artist and his male cronies.

Interestingly, the male client is invisible in Lautrec's depictions of brothel life. The appearance of men are rare exceptions (*Study for Elles: Woman in a Corset*). Lautrec was in love with the female form. The artist rarely attempts to draw the spectator into these compositions, as implicit client or as voyeur. The majority of the *maisons closes* paintings exude a warm ambiance, where women are left with their own thoughts.

The reasons why Lautrec explored this subject matter at such length are elusive. Yvette Guilbert and Edouard Vuillard suggest that Lautrec had real compassion and fellow-feeling for these luckless women. Others suggest that he was drawn to the brothels because he found a "forgetfulness of his appearance" and a healing domesticity. Some memoirs extol his friendships with some of these women. Those who remember him most fondly called him "Henri." Others addressed him as "Monsieur le Comte," and remember him praising their shoe-cleaning.

Portrait of Marcelle

c. 1893–1894, oil on cardboard; 18 x 11 1/2 in.
(46.5 x 29.5 cm). Musée Toulouse-Lautrec, Albi.
This portrait of a prostitute is inscribed with the sitter's name, but we do not know anything else about her. Her profile follows pictorial traditions established in the Renaissance—it is not clear if Lautrec intended to elevate the sitter to a higher social rank or if he was mocking the classical mode of representation.

Artistic Revolutionary

Lautrec was an artistic revolutionary, and his choice of subject matter scandalized the conservative elements of the artistic community. His willingness to focus on the women's tedious, enclosed existence in a declining, undignified system did not challenge the submissive function of a prostitute—unlike the work of the leftist, humanitarian artist, Théophile Steinlen. One might conclude that Lautrec's depictions of the *filles de maison* are contradictory.

In an exhibition of Lautrec's work held in 1896, the artist kept the brothel paintings in a back room, showing them only on request. This cautiousness may have been because of the obscenity law passed in 1890, or it may have been that Lautrec did not believe that all of these works were of paramount importance to his oeuvre. A curious parallel in this context can be found with Jacques Lacan, the renowned psychoanalyst, who until recently was the owner of Gustave Courbet's *The Origin of the World*, a close-up view of the female sex. Lacan would show the painting only to friends—after lifting a velvet cover that prevented the painting from being viewed.

Voyeurism was a rather commonplace entertainment for the clients of Paris's brothels. It was fash-

Two Friends

c. 1894–1895, oil on cardboard on wood; 23 1/4 x 31 3/4 in.

(59.5 x 81.5 cm). Gemäldegalerie, Neue Meister, Staatliche Kunstsammlungen, Dresden.

Whether Lautrec's paintings of female lovers were observed in brothels or staged in the studio is not known. This is one of eleven paintings devoted to Sapphic love, which Lautrec found intensely beautiful.

ionable during the 1890s for men to visit a brothel and watch two women making love to one another. Paintings, photographs, and pornographic prints of lesbian couples were not uncommon. The existence of numerous cafés, clubs, and restaurants frequented by lesbians was no secret.

In 1893, Lautrec painted at least eleven canvases devoted to this form of erotic love. Gustave Geoffrey published an article in *Le Figaro Illustré* entitled "Pleasure in Paris," which was illustrated with five of Lautrec's paintings of lesbians on the magazine's cover. In Lautrec's work, sex is never consummated—sexual activity is indicated through suggestive poses and an intense feeling of anticipation.

There is a tenderness is these paintings that is rare in Lautrec's work. He encouraged Sapphic inclinations, finding artistic inspiration in the poses of female lovers. The sight of two sleeping women intertwined on a bed prompted him to say: "This is superior to everything. Nothing can compare to something so simple."

The Final Years

Lautrec began to paint less and less in the late 1890s, and to drink more and more. His behavior became disturbed and he fell prey to attacks of delirium. One particularly public attack persuaded Lautrec's mother to confine her son in a sanatorium. In an effort to convince his family that he still retained some sanity, Lautrec began a series of drawings called *The Circus*, in which he showed that his memory and mind were within his command by his recall of the subjects that had engaged him in his youth. The lucid period that followed his confinement was productive but fleeting. In May and June of 1900, he spent some time in Paris. His friend Maurice Joyant wrote:

He seems to have had a presentiment, that the end was near. He put his canvases and sketches in order, and though for years he had never even glanced at the contents of the loft above his studio, he now went through them carefully.

Henri de Toulouse-Lautrec, at Villeneuve sur Yonne, at the Natansons

Edouard Vuillard. 1898, oil on cardboard;
15 1/4 x 11 3/4 in. (39 x 30 cm). Musée Toulouse-Lautrec, Albi.
Edouard Vuillard surprised his friend with this portrait painted during a stay at Relais, the summer estate of the Natanson family. Lautrec was already prey to attacks of delirium due to his alcoholism. The strident yellow trousers and red blouse may reflect Lautrec's strained state of mind.

In July, Lautrec was stricken with paralysis and was taken to his mother's home, Malromé, where he died in her arms on September 9, 1901. He was thirty-seven years old.

During his brief lifetime, Lautrec produced nearly four hundred original lithographs and posters, several thousand sketches, and numerous paintings. Due to his relentless self-criticism and hard work his oeuvre still continues to exert its fascination today.

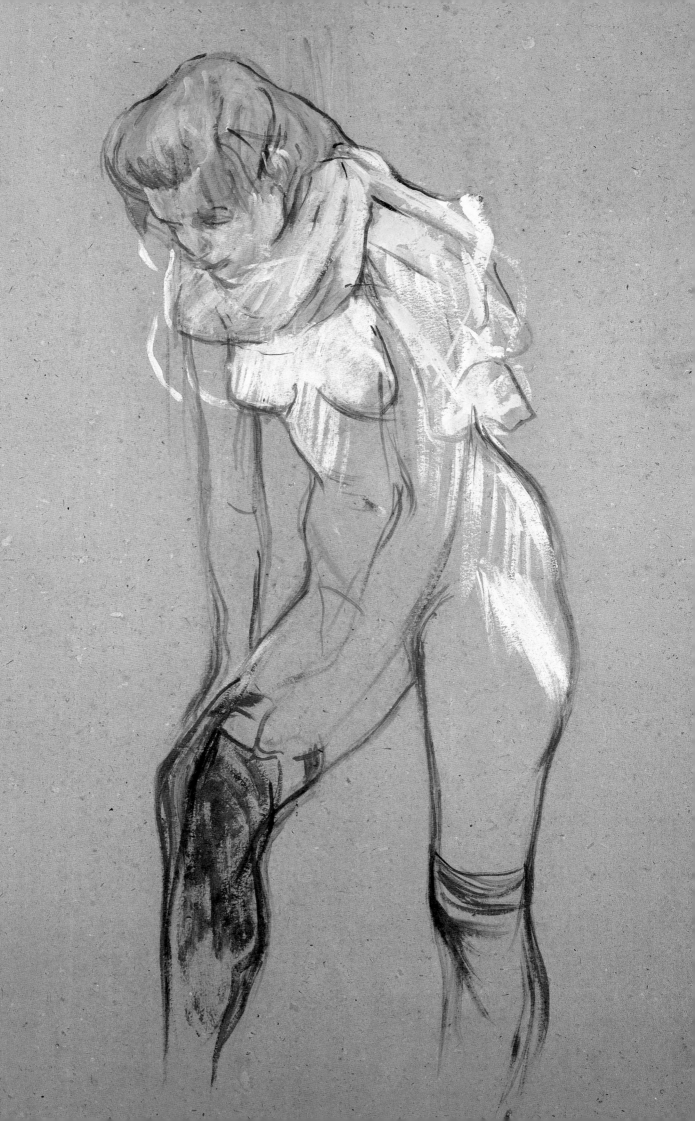

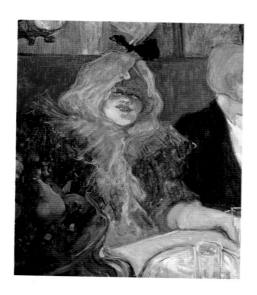

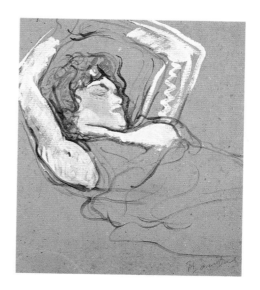

In a Private Room—
At the "Rat Mort"

1899, oil on canvas; 21 1/2 x 18 in. (55.1 x 46 cm).
The Courtauld Institute Galleries, London.
An intimate tête-á-tête supper is the subject
of this late work. The Rat Mort (literally
Dead Rat) was a famous café and restaurant
on the rue Pigalle in Montmartre. Luxurious
private dining rooms like this one were conve-
niently furnished with divans for intimate trysts.

Woman Lying on Her Back,
Both Arms Raised

c. 1894–1895; oil on cardboard; 18 1/2 x 18 1/2 in.
(47.2 x 47.2 cm). Musée Toulouse-Lautrec, Albi.
Made in preparation for a larger composition
of a lesbian couple, this oil sketch investigates
the pose of a reclining woman. Preliminary
studies such as this one were essential in pre-
paring an image in which pose and expression
finely balanced psychological and sexual nuances.

Study for *Woman Putting on Her Stocking*

c. 1894, oil on board; 24 x 17 1/4 in. (61.5 x 44.5 cm). Musée Toulouse-Lautrec, Albi.
This study was painted from life, either in a brothel or in the artist's
studio. Lautrec outlined the contours of the body in a mid-violet, and
then reworked in a royal blue. The other colors were then lightly filled in.

In the Salon at the Rue des Moulins

c. 1894, charcoal and oil on canvas; 43 1/2 x 51 1/2 in.
(111.5 x 132.5 cm). Musée Toulouse-Lautrec, Albi.

Judging from the careful preparation and substantial scale, this canvas was intended to be a major work. The faces of the prostitutes stand out against the warm plum-colored divans and dark coral pink of the walls. The faded pink and mauve evoke the atmosphere of the house and its remoteness from everyday life.

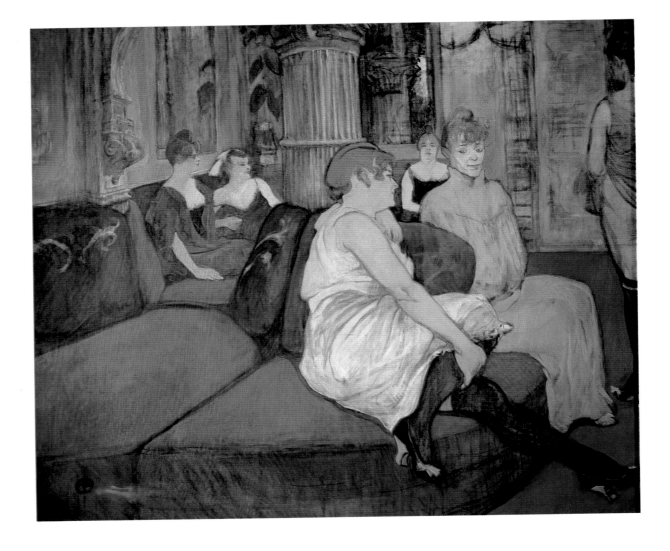

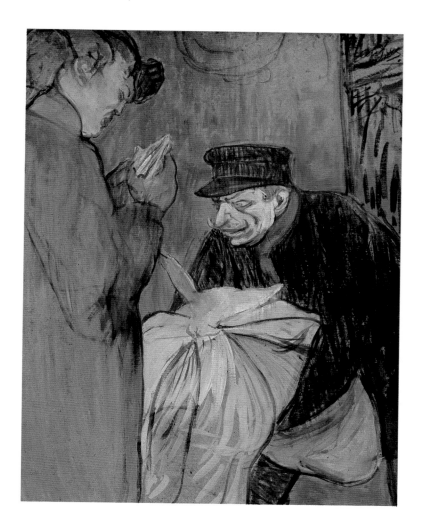

The Laundryman at the Brothel
(Le Blanchisseur de la "Maison")

c. 1894, oil on cardboard; 22 1/2 x 18 in. (57.8 x 46.2 cm). Musée Toulouse-Lautrec, Albi.
The greedy, lusty eyes of the delivery man are focused on the woman's lower torso, concealed to the spectator—who is positioned slightly behind her—by the purple gown. Busy reading the laundry bill, she is unaware of the vulgar intruder.

The Bed (Le Lit)

1892, oil on cardboard, mounted on board; 21 x 27 1/2 in. (54 x 70.5 cm). Musée d'Orsay, Paris.

In a group of four paintings dating from 1892, Lautrec depicted women in bed together, either lying side by side or kissing each other. His models appear to have been prostitutes of the brothels which he knew intimately. At the time, erotic images of lesbianism were widely available in prints and photographs.

Following page:

Study for *Elles*: Woman on her Back— Lassitude (Alone)

1896, oil on cardboard; 12 x 15 1/2 in. (31 x 40 cm). Musée d'Orsay, Paris.

This large oil sketch for the last of ten sheets of the *Elles* album is proof of Lautrec's exceptional graphic skills. Using heavily diluted oil, he handled the brush with great freedom and so achieved the quality of a drawing rather than a painting.

Nude Girl

1893, oil on cardboard;
23 x 15 1/2 in. (59.4 x 40 cm).
Musée Toulouse-Lautrec, Albi.
Certainly a study from life, the
painting shows the model caught
in an unguarded moment. Her
hesitant gesture is open to inter-
pretation. This work was made in
preparation for a lithograph to
illustrate the poem "Etude de Femme"
by Hector Sombre, set to music
by Lautrec's friend Désiré Dihau.

Woman Putting on Her Stocking

1894, oil on cardboard; 22 3/4 x 11 in. (58 x 48 cm). Musée d'Orsay, Paris.
This work is based on a study of the same subject. Lautrec has
decisively altered the woman's appearance. Her body is heavier and
less graceful, and her face has been replaced with fuller, rubbery features.

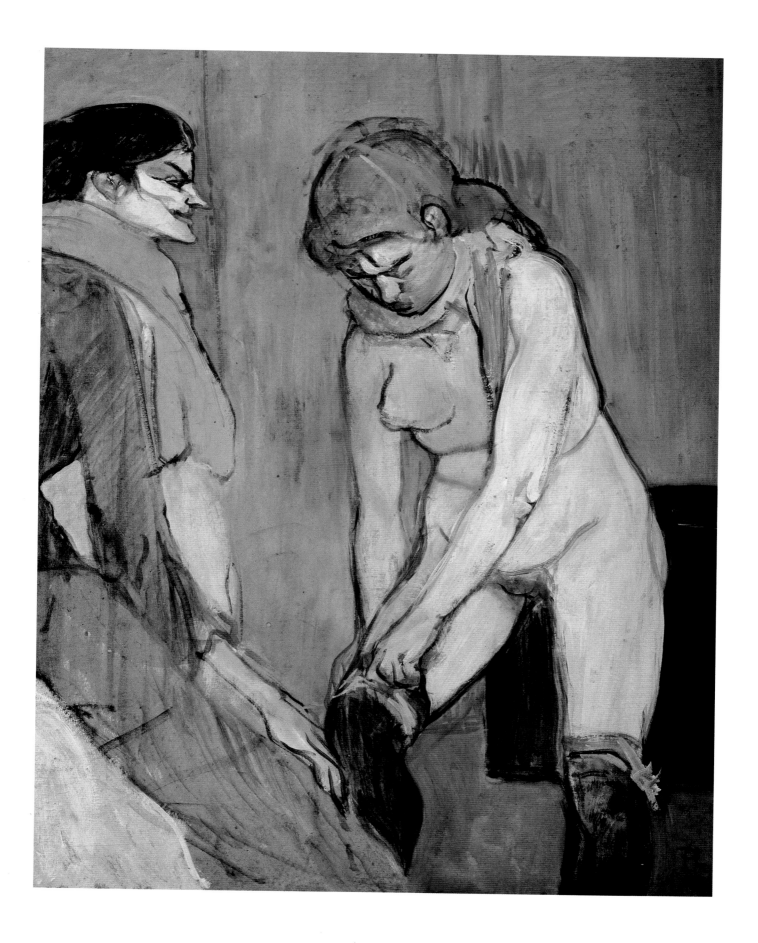

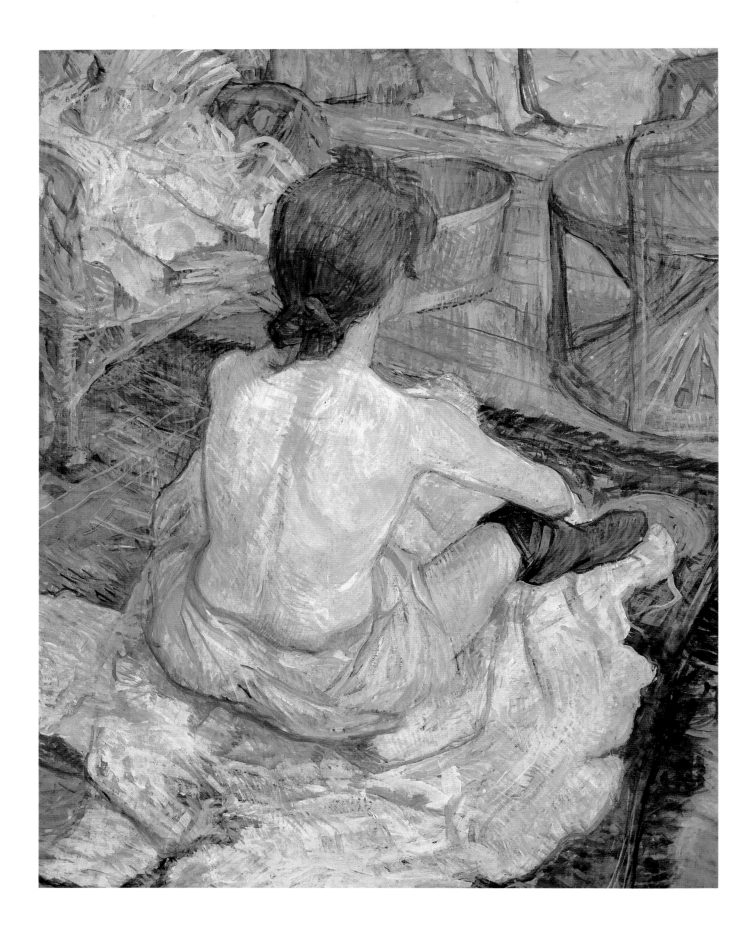

The English Girl at the "Star" in Le Havre

1899, red and white chalk on blue-gray paper; 24 1/4 x 18 1/4 in. (62 x 47 cm). Musée Toulouse-Lautrec, Albi. Discharged from the clinic in Neuilly, Lautrec traveled with his friend Paul Viaud to his mother's home at Malromé. On their way they stopped briefly in Le Havre where Lautrec had a strong impulse to paint again. This harbor town on the Channel was frequented by English sailors and its bars were staffed with British performers.

The Toilette (Red-Head)

1889, oil on cardboard; 26 x 21 in. (67 x 54 cm). Musée d'Orsay, Paris.
Most likely painted from life and directly onto the canvas, the handling of the paint is close to that of pastel. This technique is particularly visible in the yellow highlights on the model's back, on her waist, and on the carpet, which were applied among the last strokes.

Crouching Woman with Red Hair

1897, oil on cardboard; 18 1/3 x 23 1/2 in. (47 x 60 cm). Gift of the
Baldwin M. Baldwin Foundation, San Diego Museum of Art, San Diego.
The challenging pose of this nude model, who prominently displays
her breasts and buttocks, is devoid of any erotic content. One can
make out the texture of the straw mats in the background, with which
Lautrec had decorated the walls of his new studio in the avenue Frochot.

The Two Friends

1894, oil on cardboard; 19 1/2 x 13 1/4 in. (47.9 x 34 cm). The Tate Gallery, London.
In a small series of paintings, Lautrec explored the subject of lesbian love
which he could observe as a friend and confidant of the women in the
maisons closes. (The couch here also appears in the well-known painting
In the Salon at the Rue des Moulins, painted the same year.)

INDEX

Page numbers in **bold-face** type indicate photo captions.